T0015171

Notting Hill Editions is an independent British publisher. The company was founded by Tom Kremer (1930–2017), champion of innovation and the man responsible for popularising the Rubik's Cube.

After a successful business career in toy invention Tom decided, at the age of eighty, to fulfil his passion for literature. In a fast-moving digital world Tom's aim was to revive the art of the essay, and to create exceptionally beautiful books that would be lingered over and cherished.

Hailed as 'the shape of things to come', the family-run press brings to print the most surprising thinkers of past and present. In an era of information-overload, these collectible pocket-size books distil ideas that linger in the mind.

Emily Rapp Black is the author of *Poster Child: A Memoir* (Bloomsbury USA)*; The Still Point of the Turning World* (Penguin Press), a *New York Times* bestseller and an Editor's Pick; and *Sanctuary* (Random House 2021). Her work has appeared in numerous publications including *VOGUE, The New York Times, TIME, the Wall Street Journal, O The Oprah Magazine,* and the *Los Angeles Times.* She is a regular contributor to *The New York Times Book Review* and *The Boston Globe.* Rapp Black is Associate Professor of Creative Writing at the University of California, Riverside, where she also teaches medical narratives in the School of Medicine.

FRIDA KAHLO
AND MY LEFT LEG

–

Emily Rapp Black

 Notting Hill Editions

Published in 2021
by Notting Hill Editions Ltd
Mirefoot, Burneside, Kendal LA8 9AB

Series design by FLOK Design, Berlin, Germany
Cover design by Plain Creative, Kendal
Creative Advisor: Dennis PAPHITIS

Typeset by CB Editions, London
Printed and bound
by Memminger MedienCentrum, Memmingen, Germany

A CIP record for this book is available from the British Library

ISBN 978-1-912559-26-8

www.nottinghilleditions.com

For Katie Ford, Gina Frangello, Emily Miles, and Sarah Sentilles, for teaching me to see and befriend this body, in all its chaos, asymmetry and imperfection.

Contents

– Prologue –

> What you say, you say in a body; you can say
> nothing outside of this body.
> – Ludwig Wittgenstein

*D*esnudo de Frida Kahlo, a lithograph by Diego
Rivera, hangs in a light-filled gallery in a small
museum in Guanajuato, Mexico. In this portrait, Fri-
da's torso is taut and slim; the sides of her waist curve
inward, creating perfect hollows for each of your
hands. Her breasts are soft and firm – slightly lifted,
because her arms are clasped behind her head; her
elbows are the pointed tips of wings. The likeness is
that observant, that meticulous and loving in its detail.
This body is deeply known, fully seen and so *elevated*
that you can imagine it moving into positions outside
the frame, in real time and in other places. Two looped
strands of large dark beads hang just below her col-
larbone. Her shoulders look solid, strong, able. This
is a body that is loved, admired, desired. Frida's eyes
are cast downward, half-shuttered as if she's in mid-
thought. Perhaps she is enjoying her body and the
adoration it evokes from her love. This extraordinary
body, this remarkable image: beautiful, when she had
already weathered so much.

This lithograph was made in 1930, after polio dis-

1

figured her right foot in 1913 when she was six years old; after the 1925 streetcar accident that broke her spinal column, her collarbone, her ribs, her pelvis, created eleven factures in her already weakened leg, crushed her foot and left her shoulder permanently out of joint. During the twenty-nine years between her accident and her death in 1954, Frida had thirty-two operations; was required to wear a corset every day from 1944 onward; and had her leg amputated as a result of gangrene in 1953. It was this final opera-tion that likely led to the complications that eventually killed her. Speculation of suicide remains.

As an artist, Frida is famous for translating her pain into art, but people rarely know the full details of what she endured, and what such an enterprise of translation might require. Many of her millions of admirers across the globe do not realize that she was an amputee during that last part of her life, and that *all* her life her body was a canvas constantly shifting: at one point she was hung upside down to strengthen her spinal column; her body was wired and rewired, bracketed and captured and restrained and corseted in an attempt to be hemmed in, to stop her muscles and bones and joints from collapsing into chaos. She was as familiar with the edge of a scalpel as she was with the tip of a paintbrush.

Here, in Diego's 1930 likeness, her legs are thickly muscled, almost masculine. Sheer stockings hug her legs from the calves all the way to her upper thighs,

stopping just short of the shaded tangle of hair between her legs. She appears soft but also invincible, a lovely live wire in careful repose. There is no invitation in her posture, only choice – a reflection of the serenity and eroticism and intimate power of absolute trust; a woman who is willing to be seen by this artist, this man, fully and completely. Frida met Diego, twenty years her senior, in 1922 when she was fifteen years old. He had been commissioned to paint a mural at the National Preparatory School in Mexico City, where her program of study was meant to lead to medical school. This, one of Diego's first murals, was called *Creation*, and Frida walked past his larger-than-life interpretation of the beginning of the world day after day for years.

As an amputee since the age of four, I have always wondered what it would be like to have memories of two flesh and blood legs. I have always wanted someone to see me the way that Frida is seen in this lithograph. I long for a concrete, active memory of walking and running on two legs, looking at them, crossing them, spreading them, although I know this remembering would be painful. I long for the extraordinary confidence that allows Frida to be seen by the viewer without looking back to see if the body is okay, if it is offensive, if it is grotesque. But the memory of life lived on two legs is unavailable to me within the conscious process of remembering. The desired body that I long for is a fiction, and its aspiration is pointless.

When I see these legs on this woman's body whose image is mounted on the wall, taken by a man who loved her; a body that will lose part of itself twenty years after it was created, a body that has already known pain as few others have known or will ever know, I feel a longing for Frida herself, for her friendship, for her guidance, and for her love, across time and culture and experience.

The first time I saw Frida's painting *The Two Fridas (Las Dos Fridas),* I felt the impact in the intimate landscape of skin between my real leg and my fabricated leg, that small, hardworking patch of flesh that touches what is connected during the day and disconnected at night. For so long I explained to people that it was like having two Emilys, living in two bodies – one for the day, one for the night – and when I saw *The Two Fridas* in an art book my brother's college girlfriend brought home during Christmas break, I thought *yes.* I thought *you see me.* I thought *this is true.*

It was 1991, and I was still in high school. I went to the library and found every book I could about Frida, and read them in a quiet corner as snowflakes slowly twisted to the ground on the other side of the window and the sounds of Public Enemy screeched through my Walkman headphones. Many of the books mentioned that Frida was debilitated by her pain; they talked about how much and how long she suffered. And yet, all these paintings, all this output, all this art, all this beauty. I knew that pain was not a muse,

so what sustained her? *The Two Fridas* was not about suffering, it was about imagination and connection and that word my parents had started to use with me: self-love, which I was supposed to be practicing and was not. I had no model; I knew no female bodies like my own.

I learned later that *The Two Fridas* grew out of a relationship Frida developed in her mind with an imaginary friend when she was six years old, the year polio confined her to her bed. In a 1950 diary entry, she describes opening an imaginary door in her bed-

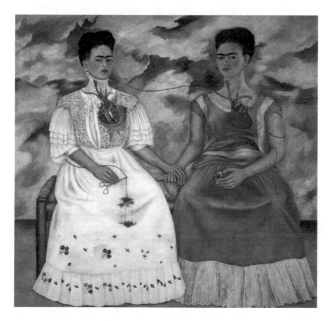

Frida Kahlo, *The Two Fridas*, 1939

room with a swipe of her hand and crossing through fields before descending to a deep place where her friend was waiting for her.

She was agile, and danced as if she was weightless. I followed her in every movement and while she danced, I told her my secret problems. But from my voice she knew all about my affairs . . . When I came back to the window, I would enter through the same door I had drawn on the glass. How long had I been with 'her'? I don't know. It could have been a second or thousands of years . . . I was happy . . . It has been 34 years since I lived that magical friendship and every time I remember it comes alive and grows more and more inside my head.

Frida's journal was published in translation in 1995. I was twenty-one years old and, when I read this passage, I wanted that girl to be me, and for that magical friendship to be mine and Frida's, one in which I could share all the secrets of my body that I believed nobody else would understand or want to know. Someone I could talk to without shame or embarrassment. I chose to try and understand the story of her body as a way of knowing or accessing mine, as if the story of her life set out a path or a trail that, no matter how difficult, I might follow. She would be my guide. I would follow her, and here is how I could move self-love from an abstraction to a reality. Together, I thought, we would discover each other. Lying in my narrow college

dormitory bed, I read an excerpt every night, listening now to the latest Indigo Girls album on repeat. I rationed every word, running my fingers over the glossy pages, mesmerized by the images, by the wit and intelligence and vulnerability she expressed. In her journal she is 'writing with her eyes', and I thought *I will paint like her.*

I took an art class, but I had no talent and my paintings were terrible; I certainly could not write with my eyes. 'I can see why you want to learn about her,' my instructor offered, 'because she suffered in her body too. Why don't you write about her?' I began talking and writing to her in my waking hours, when my requests sometimes grew angry, even violent: *give me your memories, your mind, your genius, your pleasure;* and in my dreams *I* was the imaginary girl waiting at the bottom of that magical portal she described. And when she arrived, I said *I'm real. I need you. Tell me everything.*

People who go through a crucible experience and shout from a mountaintop that the world is suddenly wonderful are liars. I have known this for as long as I've been making and holding memories. The more believable myth, and the one more challenging to embody, is to live on in the body you have been given. Frida did that with a powerful, complicated grace that has always intrigued and sometimes repelled me, her deformed body a mirror for mine.

My obsession with Frida continued. In graduate

school, when I first began writing about my body instead of pretending it didn't exist or could be forever covered up and unknown to anyone but myself, I read more fictionalized accounts of Frida's life. A character in Meaghan Delahunt's book *In the Casa Azul: A Novel of Revolution and Betrayal,* has this reaction to *The Two Fridas* at the 1940 International Surrealist Exhibition in Mexico City: 'Images of *The Two Fridas* rotate in his mind. The two figures. The same circulatory system. The two selves. The split. The unity in the split.'

In the introduction to Frida's journal, which she began in the mid-1940s when she was in her thirties, and that she never intended to publish, Carlos Fuentes describes her as the ultimate shapeshifter, able to manifest as various forms: the Spanish Earth Mother, an Aztec Goddess, a Christmas tree, a piñata, a 'broken Cleopatra'. He describes her body as 'tortured', 'shriveled', 'broken' and, in a later chapter, 'inadequate' as her pregnancies ended in miscarriage. I know this is not the full story; I know there is another narrative beneath this one that does not put her in a box. She will not stay there. On January 30 1953, a Friday just months before her death, she wrote: 'In spite of my long illness, I feel immense joy in LIVING.'

Delahunt describes *The Two Fridas* like this: 'Human hearts are precisely drawn like badges on their clothing. The hearts are linked by blood vessels which ribbon between them.'

Frida follows me. I follow her. Our traumas follow

us all, known and unknown, seen and unseen, as if asking for something. Forgiveness? Wholeness? What do they want? I see her descend into the portal of my imagination, where I wait with so much anticipation, so many questions. *Tell me the story of your body.*

– The Crippled Body (Casa Azul) –

Creation is always in the dark because you can only do the
work of making by not quite knowing what you're doing, by
walking into darkness, not staying in the light. Ideas emerge
from edges and shadows to arrive in the light, and though
that's where they may be seen by others, that's not where
they're born.

– Rebecca Solnit, *The Faraway Nearby*

I n Mexico City, in the sprawling Casa Azul that
Frida shared with Diego Rivera, now a beautifully
curated and wildly popular museum, I am thinking of
the word 'crippled' and the way people use it, incor-
rectly denoting a state of being that implies stillness,
stasis and ruin. *It was a crippling financial blow. I am
crippled by anxiety. I am paralyzed by fear.* Deformity
framed as disaster.

On this, a warm afternoon in December, I'm
strolling through the museum wearing maternity jeans
and running sneakers. I feel weighted and tired. A
sore near my crotch has been rubbed raw after days of
walking along the fragrant and chaotic streets of Mex-
ico City; buying sugar-dusted pastries; eating mole, a
rich sauce made with chilies and pepper, cinnamon,
cumin and chocolate that's like eating sweet mud;
wandering through the markets of *Colonia Roma,* buy-

ing pink slippers with glued on googly eyes that will fall off immediately after I slip them over the feet of my baby girl, who is due in three months.

The pregnant disabled body is one that mystifies onlookers as well as doctors. It invites curiosity and unwelcome commentary. During both of my pregnancies, I was given dire warnings: 'You could be in a wheelchair. Careful, careful about your weight.' My created body has been shaped, in part, by a team of men over four decades: surgeons, spine specialists, anesthesiologists, prosthetists, physical therapists, trainers. Always men. Only the attending nurses were women; including my mother, who never left my side. She was present for every surgery from the first one that crafted the initial shape of my leg, to the last one, ten years later, that molded the final version, the one I live with now. She slept in the room, in the bench by the window that overlooked a parking lot, although I never saw her asleep. Each time I opened my eyes she was sitting in a chair, next to the bed, checking charts and tubes and humming a soft song, usually the hymn 'How Great Thou Art', a Styrofoam cup of steaming, watery hospital coffee on the night table.

As a pregnant woman with a disability, my vigilance was expected; it was required, as if it had an almost moral dimension. 'Must you have a baby?' People asked. 'Aren't there other ways for you to be a parent?' One prosthetist, as I stood in my underwear and asked him to check the hydraulics of my prosthesis

because the metal joints were beginning to leak oil the way a deep, clean cut leaks blood, considered my taut, rounded belly and said, 'Careful you don't get much fatter or you'll be like a pogo stick on that thing!' When I told him, 'That's rude and inappropriate,' he quickly shot back. 'Don't be so sensitive. I didn't mean anything by it. Where's your sense of humor?'

Such physical inconveniences as swelling skin are an inevitable consequence of uneven weight distribution involved in a pregnancy lived on one artificial leg. Doctors, even now, are disinclined to treat the non-normative body with a modicum of respect (forget reverence). They stare. I offer, *it extends all the way up* to the unspoken questions. I repeat this phrase all the time, and often in public in response to a stranger's question: *how far does it go up*? It's an intimate question to be asked in an elevator by someone who doesn't bother to tell you their name before asking you to define the shape of your body so they might imagine what you look like underneath your clothes.

This funky, painful patch of skin near the lip of the prosthesis swells and throbs. Each step is painful. Is it 'crippling' pain? I am not sure. Can one be already crippled and then be somehow crippled again by a new pain, however localized and temporary? For days I've been gritting my teeth while laboring down the streets of Mexico City, a crowded cityscape that enervates and inspires. I do not want to complain, because I'm embarrassed that something so small could cause

such discomfort. The baby feels like a stone about to drop between my legs. I sit down for a moment in the hallway, and sitting down provides the illusion of holding her in, keeping her safe.

I peer through the clean windows at the green, delicately veined plants that arc over this well-tended garden, itself like a tableau from a fairy-tale. Cempasuchil flowers – bright, yellow marigolds meant to guide spirits on their return journey – droop over stone facsimiles of temples from historical periods I know very little about. I am thinking about how Frida lost her leg, about beauty and pain.

Diego was a man, a famous artist – a source, for Frida, of both disaster and delight. They longed for each other. They loved each other. They inspired one another as artists and lovers. They divorced briefly and then remarried. He had an affair with her sister Cristina, and many other women. She took lovers, women and men. Together they were revolutionaries dedicated to the Communist Party, and larger than life. Although their marriage is often described as volatile, in the first journal entry that mentions Diego, Frida writes 'I'd like to paint you, but there are no colors, because there are so many, in my confusion, the tangible form of my great love.'

The relationship has been depicted as one-sided, with a hysterical, disabled, and pathetic Frida vying for Diego's attention while he beavers away in his studio, the genius wholly focused on his art. These interpre-

tations paint Frida as the pitied woman, the dynamo ruined by misfortune, the fallen body, the beautiful woman made unbeautiful by damage and bad luck, the cripple. What emerges from the pages of her journal is a far different story; her love for Diego is a mystery, even to her, and therefore oddly sustaining during periods when she was bedridden, in part because, like pain, it cannot be fully contained or understood. On Wednesday, January 22, 1947 (one of the few specifically dated entries) after she has undergone several painful operations over a period of eighteen months, she writes:

I hand you my universe and you live me . . . I love you with all my loves. I'll give you the forest with a little house in it with all the good things there are in my construction, you'll live joyfully – I want you to live joyfully.

And then again, in 1952, in the last years of her life: 'Nobody will ever know how much I love Diego.' Imagine, if you can, such a love, such an anchor.

In the Casa Azul people stroll past and alongside me on their two legs, seemingly normal, yet carrying private and hidden ailments; the bodies of these visitors hold mysteries they do not know or may never know. I want to strip off my clothes and make them *look* at my body instead of just staring at it; to see it and take it in rather than just imagining what it might be like; to examine it with tenderness the way Diego

examined and drew Frida before she lost her leg. Had anyone ever seen me that way? Would they ever?

I feel a blender blade slowly turning through my whole body: the familiar sensation of shame. I do not show my body to strangers, rarely ever to lovers, not completely, and almost never to myself. I don't wear long, colorfully embroidered skirts with ruffles and flounces at the hem as Frida did. I have my own disguises, my own camouflage. I select outfits even for the most casual event with great calculation: what to hide, what to reveal, a cautious consideration of how much attention and of what variety I am willing to withstand or absorb or explain or contextualize. At the moment, I am mostly belly, the rounded shape the perfect place to prop a book and read at night.

My daughter has already been named Charlotte, and her nickname will be Charlie. At night I sing to her 'there once was a girl named Charlotte Black; hush little baby, don't you cry, and I will sing this lullaby'. My first child, my son Ronan, has been dead for almost a year. In the dark, they are both being formed, wound around some mysterious core: the girl without conscious effort in the darkness of the womb, and the boy in my memory, in the land of the dead, which could be dark or light, here or there or nowhere, and takes a great, cracking effort to imagine. My body is the crossroads for two lives, like some kind of medieval marker in the middle of the dirt road: Pagans, turn right; Christians, turn left.

The bitter smell of espresso floats from the coffee cart set up near the vine-covered wall at the museum's entrance. I feel happy in a way that makes me feel guilty and strange to myself. I am walking around in a tactile, almost chewable darkness, shining lights into the unseen and shameful corners of my own heart. I *hate* this, I *love* that. I am full of disbelief, aching with it, and the only fairy-tales that make sense to me are those that include a true darkness, a legitimate flaw, the soft bruise you find with your thumb while holding an otherwise perfect-looking apple in your palm.

My emotional wires are crossed, sparking in unexpected moments: I do not cry when skinny, desperate dogs are kicked in the crowded Mexico City streets, but I struggle to hold back tears when I see a billboard advertising a Mexican cookie, a tiny marshmallow man waving a red and white banner that reads 'BIMBO'. I rarely cry when I think about my son, but during the last conversation I had with my best friend Emily, her face grainy on the bad Skype connection in her London kitchen, rain striping the dark window behind her, I wept wildly and with no identifiable target. 'What's wrong?' she asked, touching the screen as if she could reach through it. I shook my head and said, 'Nothing, everything, I have no idea.'

At the Casa Azul, I can suddenly imagine all the visitors sealed in the everywhere quiet of the dead the way the rooms where Frida died were closed after her

death. Finally, the seal on the crypt has been broken, and everyone wants to see the contours and colors of the place where this genius, cursed woman breathed her last. I am disgusted with myself that this, too, is what brought me here. The rooms are heaving with people, a bottleneck of bodies hovering near the entrance to the room, vying to have a look at the place where Frida died.

I want to walk more quickly, but at this stage of pregnancy any quick movement makes me wet my pants. *Positive thoughts for the baby,* I think, and close my eyes, inhaling the scent of garden flowers, the sweet with the sour, that floats through the museum's open windows. The shadows of this liminal world – someone has disappeared, someone is emerging – are edgy, and the ideas it brings to me unwelcome. *These are crippling thoughts,* I think, and almost laugh out loud. I think of a line in Kim Braverman's novel, when she imagines the Demerol mist of Frida's final days at the Casa Azul, when the house I move through now was and still is painted 'the color of a child's first chalked sky'.

In the busy, tourist-crowded kitchen, the adobe walls are covered with heavy cooking pans and masks and *retablos* bursting with color; checkered patterns of light blanket the long wooden table. I have gazed at the narrow bed where Frida lay when she was laid up, with its crisp linen bedding, the photograph of a dead child wearing a crown of roses hanging above the plain wooden headboard. She painted here, suffered

here, recovered here, fucked here, loved here, died here. Famous for her self-portraits, which she stopped painting when she became incredibly sick, as they required looking at herself in the mirror for hours at a time. She could not bear to see herself that way.

I looked, moved on, and remembered. My son's nursery had pink walls and a framed poster of the Big Apple Circus hanging over his changing table. There was a rocking chair in the corner, near the window, where many people held him. His father and I, even after we split, cared for him equally until his death. We read to him in this room, changed him, rocked him, cried into his soft dome of hair; he spent most of his life inside those four walls with the blackout curtain always pulled to block the light that would hurt his sensitive eyes, his clothes folded neatly on the shelves in the closet. When he died and his body was taken away, I closed the door on that room and never opened it again. My parents unsealed it, unpacked it, dismantled the furniture. I kept the pieces of his crib; I will haul them around to every house I live in until the day I die.

In Frida's bedroom, you are not allowed to sit on the edge of the bed. You cannot touch the sheets or the walls, and this is a mercy. Otherwise, I fear that others – I fear that *I* – would treat the bed where the artist died as Christian supplicants treat the slab in Jerusalem, the place where the body of God through Jesus was washed after crucifixion. You might wait for

an hour in the blazing heat to enter the Church of the Holy Sepulchre to put your hands on it, pressing your handprint into the print of another until it all feels meaningless. No, I don't want anyone manhandling Frida's things, and I am glad that I, too, am prohibited from touch.

– In the Glass Room (Casa Azul) –

I've been sick for a year now. Seven operations on my spinal
column . . . I am still in the wheelchair, and I don't know if
I'll be able to walk again soon. I have a plaster corset even
though it is a *frightful nuisance*, it helps my spine. I don't feel
any pain. Only this . . . bloody tiredness, and naturally, quite
often, despair.
– Entry from Frida Kahlo's diary, 1950–51

When I enter the glass room at the Casa Azul
where Frida keeps her corsets, special shoes
and prosthetic legs, I feel as though I am entering a
sacred space with a touch of haunt. I think of Christch-
urch Cathedral in Dublin, where the dehydrated heart
of a saint was kept in a cage inside a box inside a dark,
damp room until it was stolen. The thief was never
apprehended. I think of the legs at the Holocaust
Museum, with their ragged canvas straps and scuffed
leather shoes still attached to the foam feet; objects
that never expected to be observed by strangers, or
preserved by anyone, reminders of tragic endings that
have outlived the lost lives they represent. I think of
the sections of bark that fall, whole and intact, from
palm trees in Los Angeles during a windstorm; the
next morning the street will be littered with corsets
stitched crosswise and up and down, a thick scar of

20

matching thread in a crooked line down the middle. Funky lingerie scattered along the sidewalks and piled up in the rain gutters.

In this sanctuary-like room at the Casa Azul, it is disorienting to see Frida's legs like this – the fringed red boot with one side stacked higher than the other to compensate for the post-polio asymmetry; the *fleur de lis* corset with its silky border covered with color- ful birds and animals; the casts painted with the ham- mer and sickle of the USSR; the brace with the gaping hole to represent the lost children; the artificial limb the color of palm bark, a rusty red like the dirt on the Illinois farm where my parents grew up; with a swoosh of blue and a tiny bell; a seamed place for the knee to buckle and bend; a dragon with a flared and flaming tail moving through an island of green paint. Colors spoke to Frida and she was playful with their messages. In one passage, she lifts a colored pencil from the box and free associates about the color as she writes.

Yellow was madness; Green – good warm light; Magenta – Aztec. Old TLAPALI blood of prickly pear, the brightest and oldest color of mole, of leaves becoming earth . . . Tenderness can also be this blue . . . Well, who knows!

The medical devices that thousands of people pass by as if passing a saint's shrine were invisible to most when Frida was alive, seen only by those who made

love to her, talked with her, nursed her, knew her. She may be known for making her pain public, but what I see is a woman and an artist who demanded intimacy before any deep reveal, who kept some of her most personal art hidden, even as she painted herself. The more pain she was in, the more decorative the devices became, and the less they were shown to others; this explains why many people who know Frida's art and Frida's face know very little or nothing at all about her body apart from that it experienced great pain and

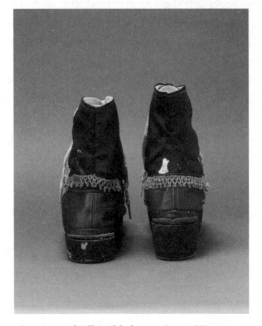

Customised silk ankle boots. Javier Hinojosa, Brooklyn Museum

suffering; this singular narrative is never the full story. And now here is the altar of Frida where you can make prayers and petitions for wholeness.

These items from her collection start to feel like a debt that's been collected from a dead body; a graverobber's stolen objects. She has been elevated to the status of saint, and people covet parts of her the way they once did a yellowed tooth, or a ragged lock of hair, or a half-moon of clipped toenail from a saint's body, living or dead. These treasures were not set behind glass, but instead tucked inside velvet and silk and hidden in a special place; a bit of shed skin kept housed in a thin wire cage and hanging from a pendant around the neck where it would collide with the heart at every step. As if a part of a different body might make the stranger who held it suddenly whole or save them somehow. Is that what we want from Frida? A story that will help us heal ourselves? Permission to use her suffering body as a tool for our own healing? I kept a lock of my son's hair in a locket for two years; but wearing it only called attention to his absence and I finally buried it at the top of a wind-swept mesa and felt a vivid relief.

My heart seizes and my face is striped with heat. Also: I understand that this is what I have done: coveted her story. And what my healing would look like is, in fact, just this: for the object I wear to be regarded as beautiful, precious, dear enough to preserve and save and admire – not just to me, but to another person.

Still, I feel like a vagabond with thief-stained hands, the way I often feel when I collect those corset palms after a southern California rain storm, the edges scraping together like the shells of June bugs that used to gather at the door of my great uncle's farm during the summer until they hit the screen and we heard them scatter like living, squirming rocks. I also feel at risk. I am conscious of trying to walk straighter, look less crippled, not allow someone to wonder what's under my jeans, or what I might have been through.

It is one thing to view an empty bed and imagine in it a body that is dead or dying. It's hard to imagine a death unless you have felt the audible lift in the air when the life disappeared, or touched the cold skin of the body from which that life has departed. Whatever the body might have been or done, whatever it might have meant to the person who lived within it – gone. After the air shifts, time contracts because this moment lasted less than a second and is now forever.

It is also easy to sanitize a death if you haven't seen one, to turn away from the gruesome possibilities of that story. Death is work; it must be worked toward, walked into. My son shifted and struggled and fought to die through the morphine syrup; Ronan was not raging against death, but toward it, and we tripped behind, screaming, pushing him forward, but also wanting to hold him back. Identities die (this boy's mother) and are reborn (this girl's mother). New identities emerge to solve a crisis, Solnit writes in *The*

24

Faraway Nearby, and I want to believe this, but what I want to do is sit down on the ground and weep. I want to drop through that portal of Frida's imagination and meet her on the other side of every possibility, as her true friend, no longer imaginary.

I want to talk to Frida about suffering, about Tay-Sachs disease, the disease that killed my son. I want to tell her that, after he was born, he was immediately turned around to his death – the distance between the two so brief, like a thin, short thread quickly snipped. I remember hitting a piñata at my sixth birthday party, the way I was marched away from the red and blue horse ribboned with gold streamers; wearing a blindfold, I was turned in circles by unseen hands until I was visibly dizzy, and then I was sent back in the other direction, my fingers turning invisible knobs in the air, searching for a door or some orienting hold in the darkness. Ronan was given a life, and then turned, still spinning, to stumble back toward his death before he had formed any capacity for memory, that prerequisite for true joy.

I will never forget this, or you. Memory is the outline of a life, what delineates shapeliness and form and meaning. We make memories, which may or may not abandon us before we die, but at least we make them. Ronan never did. It is still difficult to believe that any human being can live without narrative, without the belief in the fortitude of their temporary existence, of the shaping power of memory. Made by

my body, which was the maker, but not made to live. I feel she would understand. I feel she would let the story live on inside her without feeling sorry for me, and without expecting me to ever recover from it.

In the glass room below the bedroom and the kitchen packed with thronging visitors, just past the video footage of Diego and Frida walking down the same path we walk now, are elements of Frida's story from which nobody can turn away because they cannot live on without her, and I wonder how she would feel about so many people looking so carefully at these objects made carefully by her and for her.

I do not know what these visitors make of what they see here, what they feel about these legs and corsets empty of a body and staged behind streak-free glass, the lights turned low to prevent any fading or damage, but I know the minute I step inside the climate-controlled room I feel exposed in a way I never have before. I wince – not just due to the throbbing patch of skin at the top of my leg, but by what is revealed, how the curtain has been dropped from the body of this woman I feel as though I've been speaking to for the last two decades of my life, in dreams and otherwise. I feel like we are looking up Frida's skirt, and it makes me blush, although these legs and corsets and empty bottles of Demerol and piles of bandages are not mine and she is not here to be embarrassed by what we're seeing. Still, I feel as though my clothes have been ripped from me. I cross my arms over the

hard bump of my stomach, and walk with the others as we are carefully shepherded past the 'exhibit'.

Straight-faced security guards are on high alert for someone who might step too far forward and press their nose to the glass to try and get a better look. I am glad of this. *Back up from her,* I think, and feel like crying. *Back up from her remnants. Step away from these objects that helped her move and survive.* Was it difficult to watch a lover or trace the paint on the red boot with its bottom lift, designed to even out the length of her legs? Did she worry that she might collapse if someone loosened the straps of the corset to make love to her? Did she worry about what paying visitors to her home might think of these devices painted with birds and butterflies and flashes of color – images of flight and lightness for things that tethered you to the body, to the ground. Under a body bound, an image of freedom. That so few were given access made these objects that much more powerful. Now anyone can view them for the price of museum admission.

The corsets, delicately decorated, joyous and sad, holding the shape of the once living body, so present now in its absence. Frida painted her corsets to be objects of beauty, even after her body was rent like a garment of grief, even after her back collapsed, even after her leg was gone. She was playful with her pain; she adorned it, advertised it, knowing that there is no story that stops death.

Corsets and legs and false feet are ex-votos that

live on in the world without their owners to define or translate or embody them. Like the Mexican *retablo* painted on wood or metal that recounts an accident or illness, grief or loss or some other calamity, thanking the saints for saving the bearer. But these literal parts of the body do not create narrative independent of the body – Frida's – for which they were crafted. Perhaps this is why viewing them and trying to truly *see* feels like an act of collaboration as much as an act of voyeurism, for surely Frida knew that someday people would look at them, ponder them, *collect* them, although she hardly could have imagined lipstick printed with her likeness sold for $5.99 at the drugstore, or her face on refrigerator magnets and coffee table coasters. She even has her own action figure (not in a wheelchair, though), countless Christmas ornaments and key chains, even 'special edition' yoga leggings covered in images of her face. Her likeness is part of a matching game designed to teach young girls about famous feminists throughout history; her face is pinned to jean jackets all over the world.

As I look at her legs, I think of the one I am wearing, how hard I'm working to stay inside it, even though it's been my favorite leg since 1998, when the first version was made. Since then I have been fitted with three new Flex Feet; countless silicone sockets that become grimy and smelly from sweat and wear; and three brand-new knees. The flesh-colored 'skin' has been repainted twice when it was beginning to peel. The

shape has remained the same in a rudimentary way, but all the parts have been switched out and replaced at different moments, like a lightbulb in a lamp. Now, the structure of the leg itself is starting to unravel; I can see, at the top, the crisscross of the wet plaster that dried in a grid formation from the first mold created twenty years ago. Perhaps this is how prosthetics age; like Frida's crutches and feet and corsets, there are visible stains: a light red stain might be blood that was nearly scrubbed out; a dark stain might be blood or even the stain of shit that soaked into the fabric completely. Yellow sweat stains stripe the canvas straps of the corsets and the legs, sometimes ending in the frayed shape of a broom or a horse's tail.

If you have a non-normative body, a freakish body, a disabled body, the idea of pieces and devices of your body being viewed on their own – as *desired* – is a complicated and potent one. But only *without* the body are they considered interesting and suddenly valuable; used by the body that needs them while that body is still alive is what defines that body as *disabled,* a word we still believe connotes less than, deformed, inferior, defeated somehow. And here are these strangers, *oohing* and *ahhing* over objects they might find gruesome or repellent when attached to the body that required them to move, to love, to paint, to roam around this garden once filled with her beloved animals: her pet monkey perched on one shoulder, a tiny dog biting at her ankles.

Months later, at my daughter's first new-born check-up, the pediatrician will ask me if my leg is something my daughter might inherit, the way my son inherited the genetic disease that killed him. 'Not unless she's buried with it,' I say, and think of the bright pop of red in Frida's artful, artificial shoe, the ragged edges of her corsets, the stained straps and fraying laces. This memory of color and texture is what keeps me from standing up and slapping him.

The sorcery of grief and illness is powerful, an unstoppable tale at the end of which all people do not emerge, or perhaps they stumble into a fierce light, wholly changed. I'm here on the viewer's side of the glass, but in my mind I'm inside with the parts Frida left behind, the parts that did not die with her and that the public will inherit, dissect, judge, misunderstand, misrepresent: her legs, her rings anchored by heavy stones and knots of silver, her winged corsets, the miraculously preserved artifacts of her disappeared body. Is it her pain, or her freedom from pain, that we celebrate? How are we devoted to her, and to one another? What does true devotion require? What mental and physical reversals are necessary for us to keep living on in this ruptured world? I walk with Frida, as she wrote 'footless through the vast path'.

We are born through moments of rupture, again and again, I tell my writing students, myself, my therapist, my friends, my lovers, anyone who will listen. I wish it could be otherwise.

On this trip I have been reading *The Faraway Nearby* by Rebecca Solnit, who claims that 'the bigness of the world is redemption'. I agree, and try to get lost in this country I have never been to before, if only for the pleasure of finding my way out again, of setting and successfully completing a task, as if negative thoughts existed in an escape room and could be left behind if you solved a particular logic puzzle.

The Casa Azul is on Londres Street in Coyoacan, which brims with ambient noise that is dignified and regal by virtue of its sheer magnitude and constancy. I am sitting now on the bench in the garden. Listening as the chime in the basilica marks the hours. Barking dogs patrol rooftops while others nose through bags of garbage piled between the street and the sidewalk. The knife-sharpener winds up and down the street, advertising his skill. Someone whistles while shaking out a heavy carpet beneath a blue tarpaulin. Sirens interrupt the sound of high heels striking pavement and cobblestones, followed by the almost funereal sound of a few half-hearted trumpet trills signaling the start of a jubilant parade. A Mariachi singer fastens and swings on a single note. The odor of frying food floats through the air like fog, like smoke, like a bad mood. Somewhere the sound of hammering lifts from unseen labor. No wonder Frida loved this enclosed space in the middle of the movement around her, especially when she was confined to her bed.

Here, in Casa Azul's fragrant garden, families

mingle and snap photographs, speaking to one another in languages I recognize and others that I do not. A man sweeps the clean sidewalk with a wiry broom and a tall dustpan. Walking around the garden, I feel my baby kick. The new shape moves inside the always shifting shape. Trickster love, trickster artist, trickster friend, trickster mother, trickster child. I love the one body inside the body I try to love. Can Frida teach me this magic trick?

Each night the body is reshaped with the removal of the prosthetic, placed next to the bed within easy reach, and each morning refashioned through the act of reattachment. Each day this rebirth. But the girl's body in my belly is sturdy, active and – I hope, as I do not believe in prayer – perfect. If she is, the world will still be unsafe for her, but without this symmetry, a kind of perfection, it will hold within it a danger and power that I am just coming to realize in the first few years of middle age.

This girl inside me growing hair and fingernails, building organs and the passageways between them, is swimming in the remnant soup of my son's faulty DNA, the freakish and delicate twining that rotted his brain and killed him. At night, and sometimes during the day, I track the living, hidden baby in her domain where my heartbeats write the score of her first recognizable music. Her hands and feet across the surface of my domed belly are like momentary flashes against the skin, prints of possibility, the tiny star of a

hand appearing and then disappearing, here but not yet. Last night, I underlined this line in Solnit's book: 'To love someone is to put yourself in their place, we say, which is to put yourself in their story, or figure out how to tell yourself their story.' We are inside Frida's home, inside her story, her art, her world. Or are we?

I know Frida, I want to say to the people I watch emerging from the house, having looked at her bed and her empty wheelchair positioned in front of the canvas, as if waiting for her to arrive. *I know her, and you do not. I am the secret friend of her long-ago dreams. She is waiting for me.*

This is, of course, a fantasy. I might understand Frida least of all because I assume that I do, and therefore my lens is cloudy with the not-knowing of thinking that I know. It is a puzzle that can only ever be partially solved, for how could I possibly know her? Hegel might ask 'how do we know that we know what we believe we know?' The answer is: we do not. And this is why poetry, why art. Yes, I began to write my best work after my son was diagnosed with a terminal illness, and I wrote in bed, propped up against pillows, my fingers heavy with silver rings that made my wrists ache, my hair pushed back from my face with an elaborate headband, all in tribute to this artist who began to paint all day, into the night, after her accident in 1925, which is so dramatic it sounds like a bad dream, the ultimate terrible nightmare.

In September of that year, a streetcar collided

with the rickety wooden bus Frida traveled in with her boyfriend, Alejandro (Alex), arguably her first love, with whom she corresponded all of her life. In addition to all that was broken, crushed, fractured, and displaced, a handrail crashed into her back and came out through her vagina. The impact of the crash was such that Frida was found naked and covered in sparkling, iridescent dust; an artist, also a passenger, was carrying a packet of powdered gold, which broke open during the crash, sinking into the blood covering her body, hiding her wounds in a shimmering color. Fuentes describes this as 'rape by streetcar', and this portrait of Frida as 'terrible and beautiful'. Later, he will describe her as 'murdered by life'. This is not what Frida says to me through her work and her words; it is not what her art means to me.

In a letter to Alex a year after the crash, Frida describes it as a sudden awakening, a moment when all distractions are stripped away, when life is lived, literally, at eye level with the bone, which brings with it a particular kind of knowledge, one that certainly shines through in the paintings she would eventually create:

A short while ago, maybe a few days ago, I was a girl walking in a world of colors, of clear and tangible shapes. Everything was mysterious and something was hiding; guessing its nature was a game for me. If you knew how terrible it is to attain knowledge all of a sudden – like lightning elucidating the

earth! Now I live on this painful planet, transparent as ice. It's as if I had learned everything at the same time, in a matter of seconds.

This, to me, is what grief feels like; this is what it feels like to be told that your son has a condition that will slowly and mercilessly take his life over a period of two miserable years. The world is stripped of all but love and pain – a difficult place to live, no doubt, but also one that is saturated, at every moment, with meaning. Of course, I have never met Frida. I am not an art critic or an art historian or a visual artist. Frida lives only in the terrain of my imagination where I set all the terms of the story, but I believe she would have appreciated this, and understood.

I do not speak Frida's language literally (Spanish) or metaphorically (Surrealism). I did not contract polio, I was born with a birth defect; although, like her, kids taunted me with the nickname 'Emily the Peg Leg', and she was called 'Frida *pato de palo (peg leg)*'. (Later in life, in a letter to a friend, she will refer to herself playfully as 'Frida the Stick-Legged'.) I have never been hit by a bus. I have never thought of myself as artistic or edgy, apart from a few weeks in high school when I painted my lips blood red, drew thick black lines around my eyes and wore my father's old suits that I cinched at the waist with rope from the rodeo rope and saddle store. In Middle America, that was about as radical as we got. I have never sheltered a

dissident thinker, or been at the center of my nation's artistic consciousness, or taken a female lover in any place but my imagination. I cannot draw or paint. I have never liked being stared at, have always been, without question, ashamed of my body, for its lack of a leg, for the strange artificial stand-in, but I've remained overly attentive to the rest. Push-ups to make the arms shapely. Cardio to stay lean. Squats for the one leg, to keep it trim. Sit-ups for the taut stomach. Make it right, hold it together, stitch up the parts that you can, adorn and show off the parts that are 'normal'. The great subterfuge of the selective 'hide and reveal' of which I am an expert. I chose fitness and leggings; Frida chose what Fuentes calls 'the spectacular finery of the peasant women in Mexico...the laces, the ribbons, the skirts, the rustling petticoats, the braids, the moonlike headdresses opening up her face like the wings of a dark butterfly'.

Here in Frida's home and in her gardens, as the keeper of my daughter in the drum of my stomach, I want to be known as the keeper of the secrets of this dead woman's body. The exposure I want is based on fabrication and falsehood, linked to ego and the despair of sharing with Frida some elements of her life story that nobody wants to share, while simultaneously fearing these experiences, shunning them, wanting to set myself apart from her story while also being acknowledged for how my story fits inside hers, and vice versa – the perfect imaginary friendship. She never

intended her journal to be published; the conversation I have had with her inside those pages is a conversation with myself. I am more of a voyeur and a violator than anybody here.

A little girl with dark hair is throwing a fit in the doorway of the small gift shop in the corner of the garden. Inside, her mother examines a white embroidered dress that hangs on a mannequin, tracing the blue and red embroidered flowers carefully, considering. She turns to say something sharp to the girl in Spanish, who wails more desperately in response, refusing to be silenced. The truth, of course, is that I know nothing. The baby-stone shifts in my pelvis.

In Diego's 1930 rendering of the whole Frida (a crushed foot, yes, but a whole foot nonetheless, and one still attached to the body); in that lithograph made from life or perhaps from a photograph, Frida is nude and unassisted, her body a careful outline of lines and curves, a living space filling up the blank space of the artist's loving imagination. Her form is lithe and strong, the muscles hugging the bones. Her body is uncovered, unsevered, and therefore owned and inhabited in a way that it will never be again once it is ruptured, violated, altered, changed or scarred. When a body becomes a body that nobody will envy. When it is no longer a body that people want to fuck.

This last thought surprises me with its force: that being disabled means knowing that you are not somebody others want to fuck: without wondering

about logistics; without saying *well she's pretty enough,* as if this cancels out the missing limb or makes up for it somehow; without wondering what their friends will think about their choice. How will it work? What will go where? What will I have to do? Or, as one guy once said to me as his hands trailed down my stomach, 'What if I, like, freak out?' Or, as I once read over the shoulder of a former partner I had decided to leave, an email from his friend, 'Why would you want to be with a crippled bitch anyway?'

Why these thoughts should occur to me at this moment, I have no idea. That so-called 'fuckability' matters to me is disturbing, as it goes against my careful feminist training, my intellectual process, and, quite frankly, the truth about my lived life, in which I have had plenty of sex. But the dark thoughts spool onward: that a woman is a good woman, which means a desirable woman, when other people want her. Want to *be* her, are able to see her in a particular way that I have never felt seen, but always wanted to be: as an object of desire, as some delicious bone to grapple over, a sexy little thing that triggers a fight.

I watch from the garden the able-bodied stream from the staged museum of Frida's home to sit in the gallery, where film reels of Diego and Frida move against the screen – grainy, black-and-white images that flicker and blur. I want to shout 'Hey! Guess what? You're all an accident, a disease, or a decade from disability! Join us! You're very welcome!'

In the video, Frida wears a long white dress frilled at the sleeves and the bottom hem, and she limps across the grounds of the Casa Azul, one of her beloved dogs trailing behind her. Diego takes up space in the garden that his murals take up on the public walls of the world: he is everywhere. I feel my cheeks go hot, watching Frida limp, a gait that always looks like a struggle, even if it is not. I have always wanted to be loved for the body, not for the mind. This desire, of which I am deeply ashamed, takes arrow-like shape regardless and arcs through the air, searching. The mark is an easy one.

Reading Solnit's book about trauma and fairy-tales, I am also surprised by the sharp turn my so-called enlightened and overly educated brain has taken. What about my belief in sisterhood? I might kick it straight to the curb if it meant feeling like the prettiest girl in the room, sexy and fuckable. These thoughts are ridiculous, as well as embarrassing and frightening. I wouldn't be alive if not for my network of women friends; now I just want to be the hottest one?

Solnit also admits that 'writing is speaking to no one'. It is a 'conversation with the absent, the faraway, the not yet born, the unknown, and the long gone for whom writers write, the crowd of the absent who hover all around the desk'. Art, it seems, is the same: a conversation with the body, with the world, with the living (my girl) and the dead (my boy), with the unseen

and with the ego; and with Frida, with her words and her paintings and, especially, the self-portraits, in which she explored the gaze of others inside the gaze she returns, a story within a story.

Inside the black-and-white films of Frida, shot decades ago, she is limping in her voluminous, leg-concealing skirts across this manicured yard, where the real-time mother has now emerged from the gift shop to comfort her screaming daughter and stroke her hair, and I feel like nothing more than a crippled girl. I do not know if the anger vibrating through me is because I am crippled, or because I am still angry about my anger, or because I am angry that it all still matters to me so much when my son has died and I'm about to be a mother again. I would like to disappear into the looming plants in the garden, but there is no chance of that. People notice the belly; they want to engage, want to touch. People see this part of me, but only this part. They smile; I smile back. If my son were alive and with us, the same friendly and curious people might stare at his blank and sightless eyes, or wonder why he did not move, this beautiful boy with no cognition, no mind, no consciousness, no ego or ambition and, of course, no future.

I miss my son; his absence rings in me like cathedral bells marking the time, only time is meaningless, and every hour is the new hour. I love my growing baby with an intensity that could light this garden and all the structures of this blue house on fire.

Why do we (I) love Frida? I wonder. Do we fetishize her pain? Do we see Frida's life as a great tragedy? Yes, she experienced great pain, betrayal, disappointment, regret (so: she was human). She was also clearly a gifted artist, at the center of politics and history, crucial to the artistic life of her country and celebrated during her lifetime (so: she was lucky). Her face is perhaps one of the most recognized in the world. That she painted her body in active suffering is well known, but in most of the photographs of her, she looks relaxed and sexy and entirely at home in the world and in her form: leaning against a wall, a lit cigarette dangling between two fingers; painting at her easel in her wheelchair or propped up in her bed; preening naked in the mirror, her dark hair tied up playfully in soft pigtails trailing white ribbon. Perhaps it is because people who have

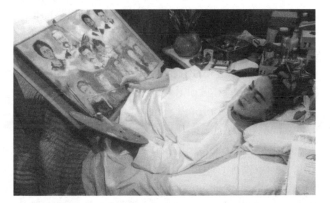

Kahlo in her bed, photographed by Juan Guzman,
Mexico City, 1952

41

never had a major operation, never suffered permanent scarring, tend to romanticize pain and suffering.

I think of all the so-called 'artistic portraits' that photographers are fond of taking of women's bodies, the ones that invite a particular kind of attention: the angles are airbrushed; the faces hidden; the hair arranged (usually swirled around the head in a fuzzy halo); limbs arranged on beds with lacy pillows and deliberately rumpled sheets in ways meant to look natural; the body prone, waiting to be claimed, plucked, fucked. *Look at this, don't you want this, don't you want to be this, don't you want to have this, come and take this.* There is no surprise in how these bodies look or what the photographs show. With the disabled body, there is always that moment of surprise. What will happen next? *Keep looking. Watch.*

In one photographer's online portfolio I remember seeing an image that repeats with small variations. Several different women, all blond with a trace of dark roots, all blue-eyed, lying belly and face down on the same white mattress on the ground. Their feet dangle over the edge of the bare mattress; their ankles are crossed, feet pointed. Their butts are round, then flat, then heart-shaped, all with tan lines. Behind them, the same backdrop of a white sheet. Women sitting on the floor with only their legs visible, so they look headless; women sitting on counters; a woman's backside retreating into a barn. The bodies are wholly interchangeable, and all of it is a lie, a construction,

an expected and acceptable and culturally sanctioned monstrosity of sameness, so boring it turns into idealism.

Unlike the temporarily different, who often use their stories of temporary disability as currency to gain affection and a fearful respect, those of us with permanent conditions are encouraged to hide. But the allure of the freak show is the same as the allure of these simplistic, staged photographs: that what was once hidden is allowed to take sudden, beautiful, unashamed shape. An idea, a thought, an image, a person, a being. *What is wrong with your baby?* People used to ask me about my son, his eyes soft and unfocused, his movements non-existent unless they were spastic. I touch my belly and hope this girl will emerge, strong and kicking, as one of the people who moves on the other side of abnormality, in the world of the normal. *What is wrong with you?* I have been asked countless times, and now I ask myself the same question, and I do not mean the body, but the mind, even though I no longer believe in even their partial separation.

Strangely, I have thought my way into the idea that disability is, as a concept, sexy in both an expected and unexpected way. The allure is in the surprise of which body will appear, and what might be done with it once it does. People noticed everything about Frida, and this created an allure that no normal body could manufacture. She was not a cliché. She was tough and fragile, vulnerable and fierce, visible and invisible.

Surrealist Andre Breton described her art as 'a ribbon around a bombshell'.

I think my bitter, broken, blaming thoughts and also believe that Frida was beauty itself, both the form and the ideal, which is always more complicated than we're told it is – even in women's studies classes – with its unexpected topography of angles, planes, colors, imperfections and asymmetries. Frida was known for her particular beauty: the single dark brow over her eyes; her embroidered dresses with petticoats and aprons, braiding and color. Those women spread out in photographs – do they look now at their aging bodies and wish those moments had never been documented? Or is it somehow comforting to know that beauty is always just that – a monument to what is fleeting and insubstantial?

Frida was talented. Just as nobody can turn away from the centrifugal force of grief, which is the most intense kind of love, you cannot turn away from her paintings. Long before the age of internet pornography that traffics in fetishes of every kind, Frida understood that a different body was itself a fetish, a whole body *milagro* like the body-part specific ones people hang from their necks, hoping for miraculous healing or a sudden solution for their various ailments: a leg for a broken foot; a whole heart dangling at the sternum to help heal a freshly broken one. In the black-and-white photographs arranged outside her preserved rooms, Frida lies in her bed, a fat, fancy ring rising from each

slim finger, a bright flower in her hair, smartly dressed, pressed, and arranged, and she is earnest to control the way she is seen, to write her own narrative that is not guided solely by pain and suffering. Frida was vain. She was insecure and needed to know that people remembered her, thought of her, still loved her.

That she didn't rise above any of these petty concerns is evident in her letters, and I love this about her. In 1927, when Alex was studying in Germany, Frida tacked on this postscript in her letter to him: 'Hey, ask among your acquaintances whether someone knows a good way to lighten hair; don't forget to do it.' Frida routinely lied about her age, and here she is afraid that the blond women will steal her boyfriend's affections. In a 1934 letter, frustrated that Alex has not written to her in some time, she writes: 'I'd like for you to write me sometimes, even if it's only three words. I don't know why I'm asking you this but I know that I need you to write me. Do you want to?' And then again, in 1947, she asks Alex: '[Y]ou haven't forgotten me? It would be almost unfair, don't you think?'

Frida also knew that desire cannot resist decay, and that we all bide our time in the land of miraculous, unadulterated desire. At some point our bodies defy us, we become part of 'the terrible exile of the abhorred' that those of us with disabilities recognize even if we do not fully know. And, of course, eventually, we die.

I stare at the pyramid anchored in the center of the garden at Caza Azul and think *I am broken,* because I

should be happy for this second chance at motherhood. But instead I feel tugged beyond the borders of my own body into my own faraway land, the contours of which are both known and unrecognizable. And in this place I am not a feminist, or a good or a kind person, but a damaged and bitchy pregnant woman, still grieving, unkindly wishing on other women the kind of despair that comes from being invisible to the gaze of the other that I have so ardently dissected, criticized and, occasionally, been able to dismiss. I am the sad, solo star of my own little reverse fairy-tale. I am fit to be no girl's mother. I cannot guide any woman through this brutal world that will judge her the way I am judging in this inescapable game of looking and ranking and sizing up. It is just as futile as tracking pain on a scale. I feel my own insignificance, my stubborn resistance to the generosity Solnit describes. My grief has gone underground. Sublimated, it remains, trembling and alive, waiting to show me who I really am.

In Frida's self-portraits, there exists in her return gaze only what she allows, a deliberate manipulation that I understand well. The rest of the story, the remainder, is hidden, held back, no permission is granted. When your body is an anomaly there is so much you do not show, so much of yourself that lies out of view, only to be revealed in a moment of trust. Full trust is full exposure: it is much more interesting than a photograph of someone's naked body partially covered, retreating from the camera, the proportions

of the shape expected, the face unseen, nothing that says more than *this is a woman* but she is a woman with no face. To love someone when you have a broken body that evokes the history of every broken body that has come before it, which is a way of evoking the notion of the body itself, requires deep surrender. *This is the body, given for the viewer,* and I realize that I have never done this with anyone, ever, in my life, although I hope someday I will.

There is something innately sexy about a decision to put something necessary on, to take it off, but only for one set of eyes. This must be true. I want it to be true. The erotic trickster. Writing to Bertram and Ella Wolfe in 1944, Frida signs off, 'Your faithful and sure friend, Dona Frida, the trickster'. Frankenstein's monster, a being with a good and kind heart, could not understand why his body mattered so much. Everywhere he turned he was met with disgust for his form, over which he had had no creative influence or control. This broke his heart, made him murderous. He could not be in his body and feel like a man, as I so often have felt that I am not a proper woman here, in this body, this abnormal woman's body that is making another body, a little girl, and who made the body of a boy that could not live in this world. I want to stand up and say to these museumgoers that they don't get to have it all. You don't get to have a whole body, and then pretend to know Frida's story, or mine, or Ronan's. I want to say *none for you. You can't be the 'we' without*

paying the price, and it is too steep, you cannot afford it. I want to say *you don't get to claim that you're an artist if you have not suffered,* although who am I to quantify or qualify suffering? *In this garden,* I long to say, *you get nothing.* The fallacy of the 'we' is such a comfort it makes me want to weep.

What do we learn in this museum that documents transient existence, as all museums do, displaying so proudly the artifacts of lost time? Have a look at the bed where Frida's body suffered and painted and died. Can you truly imagine another's dead child, missing foot, failed love affair, terminal diagnosis, truncated life, busted pelvis, new beginning? Can you truly understand or appreciate the parts of Frida's body that could not die? That instead of flesh and bone, they were constructed or altered with her own hands from plaster and wood, canvas and string, leather and plastic and paint.

– Recovery Room (1978–86) –

In all my life I have had 22 surgical interventions –
Dr. Juanito Farrill, whom I consider to be a true man of
science, and also a heroic being because he has spent his
entire life saving the lives of the ill when he himself is ill also.
1st illness, when I was 6 infantile paralysis (poliomyelitis)
1926 – bus accident with ALEX.
– Frida Kahlo, journal entry, 1953

T he sound of the cast saw is distinctive and unmis-
takable, the vibrant, shattering sound both mod-
ern and primal. My palms are cold and sweaty. My
empty bladder feels swollen. The doctor's sour breath
is only slightly veiled by a peppermint candy that he
moves against his teeth with loud clicks and sucks. (I
will think of him the first time I hear the exaggerated
sounds in a porn movie I watch covertly at a friend's
house at 2 a.m., on Cinemax, or *Skin*emax.) There are
the dark, kind eyes of the nurse with the recognizable
face whose name I cannot remember.

I am ten years old, and this is the third cast I have
had 'removed' (nobody says 'cut off', even as they
wield the small saw that resembles a pizza cutter). I am
afraid each time, and each time I pretend I'm not. 'It's
just the cast we're cutting into' the nurse reminded me
as over my mouth she slipped a blue paper mask the

49

width of several stacked sheets of paper. 'Take shallow breaths now. Try not to breathe too deeply. Stay calm, that's it.' She didn't say, *we won't cut into you,* but the space between cast and skin is millimeters only, a distance easily violated. I know by now that the body itself is unsafe ground, no part of it is inviolate, no part of it ever wholly safe.

When the cutting begins, I imagine my leg's amputation some seven years earlier. The sound, the saw, the lights, the great change unveiled: a new scar, red to the touch but already whitening; a fused bone; skin that smells rotten and trapped and stretches now, painfully, groping for air, a jaundiced, dehydrated yellow. I dream often of being awake during the leg's removal. I imagine myself at four years old, with fat, sticky palms and tangled, matted red hair, looking up to see the transformation taking place in front of me, the body moved and separated into its various parts.

The litany that would carry me through decades of my life reverberates in the medical noise of closing cabinet doors and the metal against metal of tools being set on trays and wheeled chairs sliding across clean tile floors and the earthquake in my bones as the cast cuts through the stinking white plaster: *I might look strange, but I will try as hard as I can to show everyone that this body doesn't make me who I am, that I am more than this body.*

Lying on the table, gowned and prone, I tremble with fear, but also an odd, almost exhilarating

ambition. 'All done,' the nurse says. The relief in her voice convinces me that my worries were not unfounded. The pizza cutter disappears. The war is won, the doctor is already gone, waving to me, and I am being lifted up, Lazarus girl, unembalmed, the temporarily entombed body set free. The cut cast stands upright, an insect's cast-off shell, a strange sculpture, some hollow and bewildering artifact that smells of skin and piss and waste and blood and all that the body is when it is unmasked.

Each time a cast comes off, this strange body, my body, is revealed to me and to the people watching, cutting, deciding, changing. Nobody speaks about this, of course. It is *cut here* and *there we are* and the cutter moving smoothly along the marked identified lines, like a train hugging the track. Architects of the flesh, the freak show, the forever-and-always different girl. Driven. Ambition fills my mouth like saliva. *You will show them all that you are more than the body on this table.*

'Ready to get up?' The nurse offers a rubber-gloved hand and I take it. I feel as if I've been saved from the guillotine, the chopping block, the monarch seized by mercy and the execution called off with only a moment to spare.

'Yes,' I say, and though I sit up slowly, the flimsy paper facemask resting on my chest like a silly, out-of-fashion necklace, and allow the wheelchair to slide beneath me as per hospital protocol, I imagine I am

51

leaping, strong, able. Here, in the polished memory, is where I locate the longing for Frida's muscular legs that I will see in Diego's rendering of her body decades later. The body is an incident, a terrible accident, a vessel, a by-product of chance – how could it possibly matter so much? I will learn that it does, and I will believe until I can believe no longer that it is your actions that make you who you are.

Ambition was like a phantom limb: invisible, but pulsing with feeling as if it had physical shape and presence. Did Frida feel it as well? As her body weakened with surgeries and their attendant complications, from age and illness and various heartbreaks, her costumes and outer appearance became more and more elaborate: brighter skirts, bigger rings, an additional flower perched in her carefully braided hair.

My mother massaged the phantom space where my leg had been when I told her that the missing part still hurt. She tells me I was calmed by this, by the act of comforting what was 'not-there', that liminal, limbo space; a reflection of the body that was no longer the body, but only its memory. Ambition is a concept, a kind of myth, but it aches and draws attention the way absence does, as if itself a study in absence. A striving for what is not-yet, a desire for what cannot, in the moment, be grasped or possessed. A constant grope for what is missing. This inability to close the gap between what we want and what we know we want leads to the

inability to truly know what we want and we're back to the problem of knowing once again.

People love to describe Frida as 'special', which is often a code word for 'not quite right'. That's how we described the kids in our grade school who were dutifully marched to the end of the hallway to take special classes at the same time each day. They were 'touched'. They were 'special', which was different from being 'blessed'. For a time, I thought it meant extraordinary: my body like a comet, so rarely seen that its appearance is marked by celebration.

When I was a teenager, I began to notice my body, as all girls do, in a different way. I noticed that the young bodies of girls were also noticed in a different way by boys, teachers, even parents. People seemed to regard us with a bewildering mix of wariness and excitement. We were to be empowered, young and healthy, bold and successful. I believed, watching the girls with their easy bodies, their tanned legs, their natural, loping gaits, that I was being watched, but not out of lust or interest or desire, but through a sideways glance, a backwards look. I did not think I was pretty, and I drew those standards from the same magazines everyone was reading, all the photo evidence from the same archive, an identical well of images. I knew that I was smart. I understood that I was crippled, although I bristled with this unfairness, at the chaos and random- ness of this undeniable fact, this label. *You're special,* I heard a lot, which meant (to me and to the person

telling me) flawed. I preferred the word 'crippled', but this made people recoil, which is why I wanted to use it. It matched their reactions; it hid nothing. People laughed at my jokes, enjoyed my company. At thirteen I sorted these facts in my head, scored them according to importance and moved them like checkers on the board of survivability and valuation, combining them in ways that would make me deeply untouchable but publicly reachable. If I could be perfect, if I could be the smartest, the funniest, put together fact #2 and #5, I could write my own algebraic equations related to my place in the world.

When Frida lost her limb in 1953, she had already survived so much rupture: the polio, the crash, the philandering husband and then his prodigal return, surgery after surgery on her spine (in a 1944 letter she writes about her health 'So, so. My spine can still take a few more blows'). It is easy to fetishize painful experiences like the kind Frida knew well as both tragic and identity shaping; these are convenient narratives, and far too clean. We want to imagine that Frida rose out of the devastated landscape of her life like the mythical phoenix, that sleek and terrifying and flawless bird, but this is incorrect. She was bedbound for a good portion of her life. Ragged. Helpless. Bored. And that is when she started to paint. Limbs, even in carefully planned procedures, are still amputated with a saw; they are still *cut off.*

Pain is not generative. Pain does not produce

heroic action. It only generates more pain. In *Pain Woman Takes Your Keys, and Other Essays from a Nervous System,* Sonya Huber writes, 'Pain is a cloud, a mist. Pain is like the weather itself. Though the wind and fronts are invisible, it can flatten a landscape.' Pain is not a source of inspiration. Huber describes pain as being 'soaked in this new substance, this jagged strange distracting heat'. Hardly fuel for a creative fire. In a letter dated December 5 1925, Frida writes: 'The only good thing is that I'm starting to get used to suffering.' She doesn't say, 'I'm painting nonstop because pain is my muse'.

In the group of women who have lost their children, a group that has sustained me for nearly a decade, we always say *laugh or die.* Fuentes writes about Frida that 'her voice…was deep, rebellious, punctuated by *caracajadas* – belly laughs – and by *leperadas* – four-letter words'.

In the aftermath of Frida's many accidents and wounds and operations and recoveries, I wonder if she found it difficult to look at the two-legged photograph drawn by her lover, or if she longed for it the way you long for anything that is irretrievable: ruined love; a palsied limb; a dead child; time. I wonder if I had been older when I lost my limb instead of on the cusp of making lasting memory, would my reaction to the crippled body be any different? Would I hide from mirrors? Would I ask that all extant photographs of my whole body be destroyed?

Frida was a girl when she lost mobility in her leg, a teenager when her spine was broken, and a woman when she lost the leg itself. She knew what it was like to walk with two legs, run with two legs, fuck with two legs wrapped around her lover's waist. She must have remembered it, even pined for it.

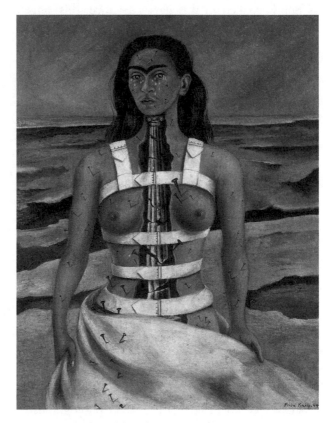

Frida Kahlo, *The Broken Column*, 1944

I was a girl when I lost my leg. My memories of the leg remain of the phantom variety alone, steeped in fantasy and imagination, the stuff of fleeting images, literal shadows, mists of memory that float and snag on the more reliable pillars of documented pain: a medical chart; a stack of x-ray images; a doctor's note. It was as if my body, before I knew it, had concocted a strange mystery for me to unravel, a new language to speak but one without words or symbols or even sounds, just imitations of all of these. A tunnel through a castle that only I could traverse. Frida's art and letters and private thoughts have helped me do so.

Perhaps Frida offers a new epistemological compass – a new orientation of understanding pain – to me and every other woman who struggles with a body defined by what is missing or taken, crushed or destroyed. Perhaps her work speaks to the hopeful belief that you can make art in that tight and narrow space, but it is not pain that is the source of the art; it is pain that becomes somewhat silenced by art's creation, if only for a moment, and therefore more possible to absorb without being saturated, without getting pulled under. And the cost of this creation is to be seen, which for anyone with a non-normative body means possible rejection.

We do not think of pain as visible until it is invisible, and then it is the absence of its presence that carries the weight, the heft, the saw's power and vibration and grind. After each of my surgeries – 1976,

1977, 1978, 1982, 1984 – the nurses made notes in my charts: *She recovered so beautifully. She's doing just fine. She's such a trooper. What a tough little cookie.* It was not until I saw that nude image of Frida, decades into being a woman and on the verge of middle age, about to have a second child (a girl) after losing my first (a boy), that I realized I had never recovered, because recovery is a lie. It was then that I became accidentally acquainted with that other girl, both hollow and fierce, who lurked, always, inside the missing bone's lost memory. So much lives inside loss. So much of what is alive is ugly and colorless and shapeless, but this mass can still bear its teeth. Sam Kean, a neuroscientist who has documented the effects of trauma on the brain in a way that anyone can understand, explains that:

until the past few decades, neuroscientists had one way to plumb the human brain: wait for disaster to strike and, if the victims pulled through, see how their minds worked differently afterward. These poor men and women endured strokes, seizures, saber gashes, botched surgeries, and accidents so horrific – like having a four-foot iron javelin driven through the skull – that their survivals seemed nothing short of miracles. To say these people 'survived,' though, doesn't quite capture the truth. Their bodies survived, but their minds didn't quite; their minds were warped into something new.

Pain is literally mind-bending; pain reshapes the brain, rewiring its circuits and transmitting strange

new messages. If our brain tells us who we are, in a quite literal sense, then pain creates a new person, a new likeness. Like in Frida's portrait, *The Two Fridas*, two bodies – both in their own ways, impossible – acting as a faulty mirror of the other. Frida never expected recovery, and she never got it.

I pretended. I moved through the world – the very ordinary, prescriptive, Midwestern and all-white world of my childhood (be pretty, be good, be still, get married not too early but not too late, be thin, be kind, be Christian, be straight, be like the person sitting next to you, interchangeable save for hair color, likes and dislikes) – as if I were a normal girl. I stacked cut wood for the stove; I shoveled the snow-covered front driveway with my brother, cracking the ice into pieces with the sharp edge of my shovel; I sold Girl Scout cookies; I took my first communion from my father and was confirmed into the house of the Lord that aligned with my heritage. Swedish, Danish, and Protestant, sprinkled with a bit of Irish Catholicism and Mennonite from my mother's side. An oil painting in a garish gold frame of a very white Jesus with long, light brown hair hung above the altar where my father preached about forgiveness and goodness. I wanted to be forgiven for what I had not yet done. I wanted to be good. I wanted to be normal and I pretended this was true, because otherwise where would I locate my value? What role could I play in the world if a piece of my body was missing?

The mirror briefly conspired with me in the great lie of normalcy. Together with my imagination, it showed me a regular girl until it did not; eventually my mirror reflected the response of others, the way they looked at me or looked away from me, the way they admired and praised me (*so brave, getting around so well on that wooden leg*) but did not desire me. *Mirror.* It would never give me the answer I wanted. But for many years, I was busy with recovery, an almost forced resurrection of the body that required focus, stamina and silence. During each surgery the body was dismantled, reshaped, reborn. The body was not happy about the changes, but had no power to resist them. 'If we take her leg, she'll have a better chance at a normal life,' the surgeon promised my anxious parents just before the amputation. This is what I was told, and I suppose aspired to live. Now I think: *What is a normal life?*

Not until the 1990s, when I was just discovering Frida and her work, did scientists begin to fully understand the phenomenon of phantom limbs, or why a limb feels as though it is still there, kinetically, when it is not. Kean notes that amputation results in a neurological blackout: 'First, a huge territory on the brain map goes black. It would be like watching the United States from space at night, with all its patches of sprawling suburban illumination, and seeing the power grid in Chicago fail.' A failed power grid of sensations. I think about eighteen-year-old Frida on

that bus, I think about the crash and the pole like a jouster's javelin driven through her middle. Gold rising like an atomic cloud before settling over her body. The brain is not destroyed, but it is altered, and altered does not mean recovered. Yet to this day, recovery is the operative word in discussions about the post-amputation period – in other words, the rest of an amputee's life. But who can spend a whole lifetime recovering? Is there energy left to do anything else? A secret part of me wondered: *What more would recovery require of me?*

'Recovering from Limb Loss' was the title of an article I read once at breakfast, as a teenager, in a magazine my prosthetist had recommended to me and to which I briefly and reluctantly subscribed. I know that the phrase 'limb loss' is not the correct description for the story we share. Body parts are not misplaced. People don't lose track of their thumbs and toes, their feet, their arms.

But my parents did not want me to feel alone in my body, which of course I did. So *In Motion* began arriving each month with issues of *Good Housekeeping* and *The Lutheran.* Interviews with new and veteran amputees and their doctors appeared alongside ads for various brand name artificial feet (Seattle, Endolite, FlexFoot), showing amputees 'in motion', which was also the name of the magazine. In every edition there was a full-color, full-page ad for this foot or the other from this or that company that doubled as an

advertisement for the sacrifice of veterans, with a bold reminder that 'freedom isn't free'. Photographs of muscled men with thick necks and clearly forced smiles stood with their arms crossed in front of an American flag, in front of a church or a school, the metal of their artificial limbs glinting in the camera's flash. At this point, my surgeries – which began at age four – had ceased, with the last being a modification operation in 1984 to make up for the one in 1982 that did not, as the doctor told my mother, 'end well'. A body with a bad ending: the phrase felt perfectly appropriate.

Inside the pages of the magazine, amputees, men and women, posed in mid-swing on the golf course. All the men were trim and white-skinned, wearing polo shirts and crisp shorts and too-white shoes; the women wore a similar get-up and were also white. I flipped through the photos quickly: amputees mowing lawns, building decks, making a stir fry in an eighties-era kitchen, flipping burgers at summer barbecues. Amputee moms lifting bags of groceries from the backs of minivans while normal children looked on. This was 1988, so these mothers wore high-waisted shorts and feathered their hair into wind-catching wings flying from each cheekbone. They were adult versions of me. They looked like damaged or incomplete versions of my mother. I couldn't bear to look at them. I pretended they did not exist, as if banishing an entire group of people from your thoughts meant you would never belong to them.

I assumed I would never be married, never be a mother (which I thought was the only normal and therefore acceptable life), although I expressed these fears to nobody except God, whom we referred to in my Fellowship for Christian Athletes group as 'our maker'. It was an idea that simultaneously attracted and repulsed me. My maker must love me to spend all the time working with my particular flesh, right? But my maker had fucked up, I thought, and left me to remake what he had started and abandoned before it was complete.

'You can have a normal life!' the *In Motion* article promised, exclamation points included. Annoyed, and also unsettled, two emotions a teenager has trouble distinguishing, I set the magazine aside and used the fallback response: anger and disdain directed specifically at my parents. We had never talked about my amputation in great detail. We had never gone to therapy before or after any of the subsequent operations that spanned a decade. Why were they bringing it up now? *Leave the story alone,* I thought, *and leave me alone while you're at it.* Except that I was starting to understand that my body *was* the story of who I was and might be or perhaps could not be, and if I did not learn to tell it, someone would tell it for me. I would be my own maker as Frida was.

'This is stupid,' I said to my father one morning. He had left *In Motion* next to my cereal bowl, and I deliberately tossed it over the handwritten prayer chain that was always in the same place on the kitchen coun-

ter where it was updated daily: *God's grace for Janeen; God's comfort for Jim; the Savior's comfort for Ellen.* A whole legal pad full of documented woe that my mother dutifully recorded with a golf pencil, parishioners implicitly trusting the pastor's wife to keep the tally of who needed what from God and why, as well as the method of delivery, although that was never clearly specified. How was comfort calculated? My mother was the prayer conduit and, with her pleasant, even-keeled voice she talked to the person requesting help and then she carefully inscribed reassuring swoops of names across the lined page, written in lead pencil, changeable if needed, as if God might always intercede or was, at the very least, given ample opportunity to do so. Writing down a petition or a wish (which is how I understood prayer) made it real. Prayers carved with the lightest touch, the outcome always open to erasure (the ailment removed, the wound healed, the disease lifted), were perhaps those containing the most power because they demonstrated the supplicant's biggest faith. 'BELIEVE IN THE POWER OF PRAYER' was written in black at the top of each page in large block letters that still smelled faintly of Sharpie. The power was certain, apparently, although its source and methods of manifestation remained a mystery. Years later, my daughter will see a photograph of a woman praying and ask me what she is doing. 'She's asking for something,' I will say. 'Oh,' she will respond. 'So she's begging.' Maybe.

My dad slid the discarded copy of *In Motion* under the legal pad and silently stacked up a pile of bills near the phone, hiding the prayer list as if it were as scandalous as pornography. Later that same year, when I looked at the pages of my first *Playboy* magazine at a party with a boy who later tried to kiss me, he said 'Would you look at her tits?'. I remembered the images of *In Motion,* and how they evoked in me the same sense of wonder and shame. And then, when my creepy new prosthetist let the dry, cracked tip of his finger cross the thin cotton fabric of my underwear that was stretched between the real leg and the fake one, I felt the same shame, the same wonder, only a wonder tinged with danger and loathing – of him, of course, but also of me. Like a fingerprint in the wrong place, the place nobody but me (I knew) was allowed to touch. How were these desires the same and how were they different?

On those mornings of my adolescence, I returned to the pages of *Seventeen* and *Sassy* that I bought with my own money at the drugstore, turning to the ads that spoke to me, the photos of normal, two-limbed girls in acid-washed, pegged-at-the-ankle Guess jeans; off-the-shoulder Esprit tops in bright swipes of pink and blue; oversized Swatch watches; earrings shaped like lightning bolts; and wildly permed hair – the uniform of the teenage girl in 1988. Part of me imagined that if I stared at those images long enough, I would be transformed into them.

At the bottom of each page of the legal pad was a prayer particularly for me, and I stayed in the same category: *God's grace for Emily.* Line after line of this singular wish. I was forever waiting for grace it seemed. What did it mean? Forever in recovery. A state of limbo. I imagined grace landing on me someday like some dark and terrible bird that I would inadvertently dismiss without knowing it had ever arrived. This terrified me, and yet I would often imagine it, lying in bed at night, rolling over me like a curse, rolling over me like the bus that collided with a car in 1925 and created the accident that broke her body and plunged an iron handrail through her middle. I had read about Frida in a small book – more of a pamphlet – that I stumbled upon at the library, the only book I had ever willingly picked up that had 'disability' written on the cover. I think it said 'Famous Disabled People', and I took it to a dark and quiet corner of the library and read it, heart pounding, as if I were reading forbidden, salacious, impossible prose. *Prayers for Frida; God's grace for Frida; Free Frida from this great and crushing pain.*

Years later, when I had my own child and was recording the frequency of his wet diapers and the consistency of his poops and times and duration of his feedings, my mother gave me a smaller legal pad that reminded me of the prayer list. This one documented the same rituals of motherhood she had experienced with me, a language of task and time that I was just

discovering. *Nap, 25 minutes. Wet diaper, 10 a.m. Prunes at 8 – poop at 9! 20 minutes left breast, 20 minutes right breast.* Activities that mothers have tracked since the beginning of time. Among my mother's group of seventies-era moms, my mother was called a hippie (in an unkind way) for breastfeeding instead of using formula ('And for six whole months!' someone once exclaimed to her in a voice, my mom later told me, that made it sound like she'd robbed a bank). My mother, who was a virgin when she married at twenty-three, didn't utter a curse word until she was in her fifties, and wore wide-collared polyester shirts and long skirts that went down to her ankles. She was considered a radical within the traditional Scandinavian transplant circles of 'nice' women and morality-abiding men, governed by God (and His grace, presumably, which did not extend to anyone in the so-called counterculture, a word my mother would not have understood).

My mother's journal, however, was different from other baby journals of its kind. Yes, my various bodily functions were recorded. But so were my moods, my movements and, later, during all the surgeries, the levels of pain. All the entries bore the same title: 'The Recovery Room'. Here it gets tricky, for who determines the metrics of pain? How is it quantified? Virginia Woolf believed it was indescribable. And yet my mother tried. My pain was graded, ranked along a typical ladder scale of 1 to 10, as if by moving it up and down she could find a way to diminish and then

eliminate it entirely. *On a scale of 1 to 5, seems like a 4. Grumpy. Refuses crackers (even oyster!). Won't drink juice! Phantom pain – how to score it? Ten today. Bad day. Traction.* How to rank the pain of what is lost? I thought of this intimate pain scale years later, in algebra class, when I asked what the solution to the problem *meant*. How big is that answer? Is that combination of x's and y's as big as a kitten? As small as the head of a pin? 'It's just the *correct* answer, Rapp!' the teacher shouted, although this never seemed an adequate explanation.

Frida, writing to Alejandro Gomez Arias (Alex) in April 1927, has this to say about the experience of traction:

How I wish I could explain to you, minute by minute, my suffering…Friday they put the plaster cast on me, and since then it's been a real *martyrdom* that is not comparable to anything else. I feel suffocated, my lungs and my whole back hurt terribly; I can't even touch my leg. I can hardly walk, let alone sleep. Imagine, they hung me by just my head for two and a half hours, while (the cast) was dried with hot air; but when I got home, it was still completely wet.

God's grace for Emily. That unwavering belief, written again and again on the thin blue line of a yellow legal pad, propping up the list of so many others who were presumably in need of assistance. What was God really making, I wondered? And what did grace

look and feel like? Where is the grace of a woman when her body is no longer intact, but in pieces?

In many tales of transformation, the girl enters the forest, literally or metaphorically, and is changed. Perhaps she is saved by an animal with which she is briefly aligned, or by her own sharp wits and clever mind. Perhaps she perishes among the dark trees and remains unsaved, then later used as a cautionary tale for others who might be tempted to follow her rebellious example. When a girl like me, like Frida, loses a limb and gains an artificial one, she learns to appear and reappear on an almost daily basis – strap it on, strap it off. This is a kind of art form, to change so often, to hold the before and the after together in one's mind as well as in one's body. In mine and Frida's story, in this reverse fairy-tale, in this tale of two tricksters, as Frida often described herself in paintings and in letters, nobody overcomes anything. A broken back stays broken. When your limb is lost, it stays lost. We shift shape by the day, by the minute, by the hour, but at a significant cost.

In the 'breakout groups' at the amputee support conventions I reluctantly attended as a teenager, another young female amputee and I chastised the older attendees who were openly ashamed of their bodies. We said *I am crippled* in loud voices as a way of reclaiming the word, thinking this made us strong; we imagined ourselves as impervious stars of youthful potential, weird bodies be damned. We thought we

could convince people that we were normal and worthy by calling proud attention to our difference, a strange and ultimately faulty strategy. And I am remembering the men, wearing khaki pants and polo shirts – there was an intentionally nondescript uniform, it seemed – who were later identified as amputee 'devotees'. They lurked near the tall plants in the hotel lobby, leaping out when you walked by, saying, to your face, *a propos* of zero, unbelievable things like *Nobody will love you because of your leg. But that's the thing I love best about you, the thing I want.* Spoken together, the statements were terrifying, both contradictory and true.

Crippled and proud! my amputee friend and I chirped to one another from our separate beds in the convention hotel room we shared. And then we turned our backs to one another, retreating into our private and unspoken grief, made more miserable because we pretended it did not exist.

Devotees in my experience were primarily white, middle-aged men, pudgy around the middle and in the arms. They were especially fond of young girls – young, pretty girls – which my friend and I, as we linked arms and hurried away, reminded one another that we were. We were pretty. We didn't need those losers. *You're gorgeous. No, you are. You're awesome; it's true. Fuck those assholes.* It was the nineties, after all; we were young and living in a decade of hope and prosperity, budding feminists newly acquainted with the history of the struggle but solidly second wave, and

70

we believed that being empowered and independent was our birthright. We took kickboxing classes so we'd have self-defense skills if a man tried to attack us. We listened to the latest Indigo Girls album and drank pink wine from a box and planned our feminist revolution. We stopped shaving our legs and our armpits. We threw away our makeup and dressed like boys, in baggy jeans and flannel shirts. We thought we could will our bodies to matter in a culture that had always seen them in a limited way.

My friend and I were adamant: the devotees were wrong and gross and horrible. *Disgusting and worthless:* our voices echoed through the hallways we moved down. But what spun through my mind all the time, every moment, without ever being spoken aloud: *what if they're right?* We were careful not to look at one another – afraid of the fear reflected back in the other's face – until long after we had cleared the lobby, leaving behind the gauntlet of those grasping men as we returned to our teenage bubble of concerns: hairstyles, music videos, and who liked whom, and why, and how.

These devotees were devoted, they claimed, but to what, to whom? To loving the cast-offs and the untouchables, it seemed, and they wanted credit for that, appreciation from those of us who, according to their logic and blatant hierarchy of desire, were undesirable. They were such good and compassionate men, could we not see how open their minds were, how big their hearts? We could not. I did not want to

exist on some outlying planet in the galaxy of *eros*. I didn't want conditional desire; I did not want to dwell, strange and terrible, in some outer ring. I wanted to be in the bull's eye of somebody's wanting, but not in a way that obliterated all of me for the sake of one aspect of my appearance and experience.

'I'm attracted to your pain,' a proud, self-described devotee once told me. I had competed (badly) in a swimming race on Long Island, and we were sitting in the restaurant bar before the awards dinner. I was nineteen and drinking lemonade, and still on a very strict diet of 1,000 calories per day (which explained my terrible athletic performance). He was fifty-five (I asked) and drank two martinis in the space of our twenty-minute conversation. He was proud to call himself a devotee, he said, letting his eyes wander down the rust leotard that I'd tucked into my waist-cinching jeans. He told me I had pretty hair, a classically beautiful face, a 'slammin' body. 'He'd been watching me,' he said. 'Uh-huh,' I responded, and pressed on, feeling that concentrated lightness unique to subsisting on diet Coke and carefully counted and painstakingly consumed tortilla chips. Years later I would read this in Margaret A Lindauer's *Devouring Frida*: In 1925: 'Kahlo was impaled on a metal handrail that entered her lower torso, breaking her spinal column and pelvis and exiting through her vagina.' When found, 'she rather bizarrely had been stripped of her clothes and covered with gold glitter that another passenger had

been carrying.' The wounded body anointed. The devotees must love this story; the sprinkling of glitter over pain, as if dressed-up pain might be other than its wordless, howling self.

Since Mr Devotee was already married, or at the very least wore a ring to indicate such, it felt safe to ask him about his particular desires, devoted as he claimed to be to *women like me*, and I also wanted to demystify the men from the hotel lobby planters. If I could make these men real, perhaps I could banish the fear about what their fantasies meant for my future. Perhaps if one got rough with me, I'd be emboldened to use one of my newly acquired self-defense moves – maybe an undercut punch to the chin to rattle the teeth – rather than cave to his insistence that I had to take scraps of love and sex from only a few willing men who exhibited an obvious sexual pathology.

I asked him a series of questions. His wife did not wear artificial limbs, he explained, 'because she has me'. He looked over his shoulder and my eyes followed his to where she sat on a bar stool on the other side of the restaurant, chain smoking. He preferred to carry her, he explained, because it was sexy to see her helpless. 'It's erotic,' he whispered, leaning over his martini, 'knowing she needs me so much.' I leaned away. He leaned in, going on to say that he had saved his wife from a lifetime of loneliness and was she not lucky and maybe I too would hit the husband jackpot and *find a man like him*. I grew up in a church, and

I knew faith when I saw it, and I saw that he truly believed this. 'I'm one hundred per cent devoted to her,' he claimed, but he didn't look at her when he said this, he looked at me.

Later, when the man's wife appeared in my dreams, which she often did, she was covered in glitter and pinned to the bar by a length of pole, a pile of half-lit cigarettes smoldering around her remaining foot. She is in agony, and the man's mouth drips with desire, his cock as hard as what impales her. He is a predator, not a man. He is proud and horrible and guilty and full of rage. I would wake up from these dreams and almost vomit. 'I've got to go,' I said, lying to Mr Devotee. When I stood up, he reached for me, and I didn't think to hit him. I stepped back and walked away. How dare he think that I should be grateful for his advances? How dare he see me as some version of 'terrible beauty', as Fuentes describes Frida's shining, shattered body after the crash. Back in the hotel room, I sat down and cried and promised myself that I would never accept affection or desire just for the sake of it, as if I needed to beg to be noticed, to be loved. Not a fighter, maybe, but also not made helpless by pain, or by lack. Pain was not a muse and never would be, in any shape or form.

Devotees do, in fact, attach to the moment of the limb being severed from the body. The act of sexual penetration – and the joy of it – is linked to the imagination of this pain. The pole through Frida's

pelvis. The surgical saw. The moment of rupture. *You are attracted to the pain of a child,* I wanted to scream at the devotee when I saw him later, lingering near the entrance to the bar as if waiting for someone. *I was four years old. There's nothing sexual about it. And there's no way you can imagine the pain; it doesn't have words. It doesn't have shape. You can't touch it or penetrate it with any part of your body.* I wanted to be sexual, which I was taught to understand as sexualized, not fetishized, but I didn't understand the difference between the two, and I didn't equate either with respect or love and certainly not my own pleasure. Was becoming someone's fetish the only way to be sexy if your body was not 'normal'? How was being fetishized different from being desired for having a unique, unrepeatable shape, or would the one leg always and forever be the only thing that mattered? It was painful to think like this – where would that fall on the prayer list?

On one Christmas Day in Mexico City, I stood on a moving walkway, making its slow way past the shrine of the Virgin of Guadalupe. Standing next to penitents clutching rosaries on this conveyor belt of faith, all of us inched past the centuries-old image that attracted millions each year. I looked with a skeptic's eyes. A woman standing next to me voiced ardent prayers for protection and healing in Spanish; I did not understand what she wished for, but I recognized the tone. When we passed the wall where the Virgin's likeness hung, all the believers crossed themselves in unison.

In a 1945 speech, Frida said, 'What I wanted to express more intensely and clearly was that the reason why people need to make up or imagine heroes and gods is pure fear . . . fear of life and fear of death.'

God's grace for Emily. The Lord's healing hands for Frida. Jesus, Jesus, remember me.

– Violation / Veneration –

Frida's leg was made in New York City in the 1950s; mine was made in Denver in the 1980s. My prosthetist, a man with dark hair and waxy skin, who looked at me the way I wished boys my age would look at me, marked the places where the wooden leg attached to my body by a strap that became increasingly worn each day and soaked with sweat, until eventually the fabric wore thin, and then it started to shred. When I started my period later that year, the strap became blood soaked and rank, and my mom spent hours trying to wash away the stains, clean away the stench.

There was a gap, as the prosthetist described it, between my hip and the top of the residual limb that he needed to 'tweak', and so he used Revlon's Cherries in the Snow lipstick to make a series of red, waxy slashes like tiny misshapen mouths kissing around my crotch and upper thighs, to mark his tweaks. *Okay, just there* he said, and the cool wax slid over the scarred skin. When he left the room with my leg to power up the leg saw in the back (to carve down the foot, the thigh, the calf), I looked at myself and thought *Frankenstein's monster,* stumbling into his life with his body carved up the way a butcher marks the parts of an animal: haunches, breast, thighs, rump. We were reading

the book in English class. At night I would read two pages, then fourteen, then fifty, shut the book, place it in bed beside me, and weep. There was such powerlessness in difference, which created, it seemed, not just a barrier to success but also a barrier to love. Who could stand it?

Then I stopped eating and, for a while, I found power. I was the pure, starving, virginal, intact woman, but with one part that would never be intact. It was that severing I sought to overcome by silencing all other desires.

*

Physical ambition is circumscribed by ritual. The body is its own ritual that must be organized, hidden and, if you are a woman with a disability, shut down for public consumption (*hide the leg; be thin; don't slip up; don't make a mistake*). At sixteen, I consumed the same foods in the same order and at the same time. One piece of dry toast (7 a.m.). One chocolate milkshake (11 a.m.). Three tortilla chips (3 p.m.). One chicken breast and three mini spears of broccoli (6 p.m.). This continued for nearly three years. My face went slack and model-like, for which I received a constant barrage of compliments. My body was a lean, lethargic wire that slipped into clothes like an eel into water; I wore everything with an angular and boyish grace. I had been smart, but now I was pretty, or so everyone told me. I thought, *this is easy. I can do this forever.*

At night, the grind of my stomach told my otherwise. I pressed my residual limb into the back of my right thigh to remind myself that difference was ugly, and I had to be stronger, thinner, smarter or I, like Frankenstein's monster, would find myself on the outside of the world looking in. I circled the residual limb with my thumb and pinky finger. I was holding fast to this weight (90 lbs). Steady and aerodynamic, practically feather-light, I would rise to the top.

I did rise. I succeeded in school. I wore a size two, then a zero, then a double zero. I went to college and continued my ritual until the need for brain power, for a life of the mind, overrode my obsession to be skinny. I wanted to be able to *think*.

When I met a new prosthetist when I was twenty, on the wall hung photographs of disabled athletes victoriously crossing finish lines, all men. I wondered aloud to a male amputee why there were no pictures of women amputee athletes. 'Nobody wants to see the body of a disabled woman on a poster,' he explained. 'Competitive sports are meant to be aspirational.'

I nodded. I agreed with him. Like every image of a woman, there were two sides to hold. Keep the one body hidden; the other, which might have some acceptable parts (for a woman it must be beautiful and lithe and fat-free and preferably tan with a head of blond hair attached to the whole mechanism), may stay in the open. The Two Emilys. Show only the connected body. Keep the separated body hidden from view.

*

When I became a mother, food changed shape and color and purpose. First, I fed my son breast milk, then solid food, and then, after he was diagnosed with a terminal illness and was in his final days of life before he turned three years old – that after that would be the forever after – Pedialyte every two hours through a thin tube in his nose. I varied the flavor although he could no longer taste, suddenly consumed by this need for him to enjoy something, and food seemed the easiest thing to provide. He had Tay-Sachs, a disease of the brain, a genetic disease that I was responsible, in part, for having given to him when he was created. 'I can't imagine how I'd feel about my body if I hadn't made a perfect child' a woman said to me once, in the drugstore, when I had Ronan in the front pack. I screamed at her, I don't remember what, but part of me believed her. I had failed at the mothering enterprise; I had made my child the wrong way. As punishment, the world would unmake him slowly, bit by tiniest bit.

In quiet, middle-of-the-night moments when I was alone with my son, I thought about starvation. Voluntary emaciation. I lost all ambition for those two years while Ronan was dying, all ambition except to live without hating everyone and myself. I felt both monstrous and liberated. I ate whenever I wanted to, whatever felt good. I watched my son's pleasure in food while he still had it. I marveled at his lack of ambition

or desire, a body stripped to its barest necessity, its most singular presence. I remembered lying behind the sterile curtain during my C-section when Ronan was born, the tugging and the pulling and then, this part – this person – removed from the body. I looked up to see the body of this person who made my body one of a mother. And yet I failed him, I believed, as if anyone could exercise control over the multiple recombination of parts, DNA, cells and matter.

My ambition now is only this: to live without always feeling despair. Was this Frida's ambition? There is the body I long to have, the life I think I long to have, and then the body I have been given to receive, the body that I embody, the life that I live, which is mine, both strange and beloved. I embody the shadow sides of the same bright self.

Frida's 1939 response to selling a canvas to the Louvre in Paris: 'I had expected this only after my literal death. That is the way with women artists. When she is dead, she cannot harm you.' Art that erupts from the nexus of real friction, real struggle, is a subversive enterprise producing potentially dangerous, convulsive beauty. The suffering woman – is she too easy to love because she is not perceived as dangerous, when in fact she is a ticking bomb? The Two Emilys. The Two Fridas. We walk together in all the spaces that unite and divide us. In my efforts to understand her, I begin to better understand myself.

– Montaigne Visits Victoria's Secret –

As a matter of fact, or beside the point, it doesn't matter, it's
said as a common proverb in Italy that the person who hasn't
slept with the cripple doesn't know Venus in her perfect
sweetness. Luck, or some particular accident, put this saying
in the mouth of the people long ago; and it's said of males
as well as of females. For the Queen of the Amazons replied
to the Scythian who invited her for love: 'the cripple does
it best'. In this female republic, in order to get away from
male domination, they maimed ('amputated' or 'mangled')
during childhood, arms, legs, and other members which gave
them an advantage over the women, and they used the men
only for what we've used women in fact. I would have said
that the swaying motion of the cripple might bring some
new pleasure to the toil (of love) and some bit of sweetness
to those who try it, but I've just learned that even ancient
philosophy was decided in that; it says that since the legs and
thighs of crippled women, because of their imperfection,
don't get the nourishment that is due them, it follows
that the genitals, which are right about them, are fuller,
more nourished and more vigorous. Or that, this default
prohibiting exercise, those who are tainted use less force and
come more fully to the games of Venus.
– Montaigne, 'Of Cripples'

From 1992 to 1996, when I was home on holidays
from my small liberal arts college in Minnesota
and staying with my parents in Denver, I worked at

Victoria's Secret in an 'upscale' mall near downtown. This was before the store became a violent study of the color pink, awash in saccharine scents and glittering eye shadow. In the nineties, 'The Secret', as my father called it, carried only a few fragrances (one of which was called 'Rapture', a somehow-sweet musky rose that trailed me like a stinky cloud all through college), and still sold flannel pajamas and underwear that actually covered the majority of the flesh on one's ass.

Our sales mantra at Vicky's was 'Greet, Guide, Go'. Greet the customer with an exuberant, sing song chirp – 'Hi there!' – before guiding them to the item they requested and then moving on to the next customer. Sell, sell, sell . . . but be nice about it! Most of my time was spent with women in dressing rooms doing bra fittings, listening to sad litanies about how much they hated their bodies. I also hated my body, so I was careful to only give compliments and I worked hard to find the most flattering fit from our selection of bras, which, at the time, bore women's names that were popular for babies during the 1970s: Ashley, Courtney, Jennifer, Emily. I still have some of these bras, rolled up in a single file row in a drawer, like a class roster. I sailed through these encounters, depressing as they often were, being super nice. I perfected a sing-song syrupy voice and a plastic smile. Venus in her perfect sweetness? Hardly. The only woman who did not say negative things about her body had just had a double mastectomy, and she said, clearly and matter-

of-factly, 'Just give me a simple push up.' She didn't want the smiling teenager in her flowered dress and retail-worker flats and fresh manicure (this last bit a requirement of the position) to parade a series of bras in front of her as if we were on the *Price Is Right*. She was just happy to be alive. I dropped the nice act and simply got her what she needed without ceremony. She was my most memorable – and favorite – customer during the four years I worked there.

I began my time at Vicky's in the 'flannel room', where each night after closing I 'sleeved' the long *Little House on the Prairie*-style sleep shirts sprinkled with demure flower patterns that matched the store's light pink flowered wallpaper. Starting at the front, I folded the sleeves toward one another, as if there were hands inside and I was bringing them together, the way I had seen my father move the hands of people in caskets before a funeral, right hand on the bottom, left hand on the top. I worked my way up the angled rack so that, when I was finished, all the nightgowns looked like they were hugging one another. After wiping down the counters, vacuuming the carpet, and organizing the panties in each room, the manager lined us up outside the closed black gate, rifled through our handbags checking for a pilfered pair of panties or a bra (this ritual occurred each time an employee ventured into the mall for break), and then offered us a puff on the nose from the new makeup line that was, at that time, just emerging. 'This powder smells so

good, doesn't it?' she would say, her always manicured hands delicately raising the glittery goods to our tired and sweaty faces. The girls twittered restlessly, anxious to flirt with the boys (all blond, and wearing the requisite nineties hairdo for dudes, a flop of hair over one eye, short at the back) closing up across the hall at Abercrombie and Fitch before hopping in their Jettas to go home. I didn't have a car, so my dad often picked me up. He'd sit on the benches outside the store, looking creepy in a gray sweat suit and a ball cap. 'Who *is* that guy?' one girl asked once, her tiny nose turning up. 'That's my dad,' I replied. She seemed shocked. Any street cred I may have hoped for became a distant dream when the girls watched me and my father push the Volkswagen bug to give it a running start before we both jumped in and he started the engine. Not only was it weird that I had no car, but my dad's was practically falling apart, and we took side streets home to avoid the possibility of getting stuck on the freeway.

There were a few rules at Vicky's: employees were strongly encouraged to get manicures, there was an unspoken rule that no girl (we were always girls, never women) wore anything larger than a size six, and we only had thirty minutes for our lunch break, regardless of the length in work shift.

Although the work environment was banal and silly – GREET! GUIDE! GO! would ring in my head for hours after my shift ended – I liked wearing

my favorite dresses to work and I was good with customers. Standing up for twelve hours was grueling but seemed a better alternative than pouring frozen yogurt or serving up Cinnabons. I was saving up for my junior year abroad in Ireland, and I took every shift they would give me.

When I moved up to bra manager in the back room one Christmas season just after the launch of the so-called Miracle Bra, I began to like my job less (which had something to do, no doubt, with the Santa hats we were forced to wear during December), and because I came face to face with the brutality of being a woman in a world that judges her so harshly by her appearance alone. Every single woman I fitted for a bra ('Did you know,' I would chirp, sliding the measuring tape from around my neck, 'that ninety per cent of American women are WEARING THE WRONG SIZE BRA???') confessed to me how much she hated her body. It was not: 'Wow. Check out what this Miracle Bra does for my rack!' or 'My back feels better. You're right – I must have been wearing the wrong bra size!' Instead it was: 'I'm hideous.' 'I wish you could measure me with your eyes closed.' 'Can you come in here and tell me what you think? If you were a man and you saw me in this, would you barf?' The women were willing to show their bodies, but hard pressed to find anything beautiful about them.

I could hardly believe it. I envied every woman's body that waltzed into one of my carefully tended

dressing rooms in my closely managed area of the store. All of these women had what I did not: normal bodies, easily moving bodies, bodies that did not come apart like a cheap Barbie doll. I made frequent trips to the stockroom in the back to have the hinges on my wooden leg oiled by the guys in the stockroom, a fact that endeared me to them (I routinely acted as peacemaker between stock and management), but made me feel hideous. What was I doing, floating around the store, pretending to be in the business of making women feel beautiful while hating everything I saw in the mirror? And then to have that same body hatred reflected back at me, in every single customer I encountered. When it came time to change the huge marketing cardboard foldouts that sat around the store, photographs of women staring demurely at the camera, maybe a single fingertip hovering at the edge of a painted lip, the body perfect and slick as a doll in a push-up bra and panties, I happily volunteered to make a visit to the dumpsters where I could see those images crushed by the giant trash compactor. *Be gone*, I thought, trembling with envy and hatred; but, of course, the images stuck.

Throughout my brief tenure as the bra girl, I stopped expecting any woman to come in and express anything but self-loathing for her body. Instead, I blocked it out. I pretended not to envy them. I organized my bras, finished out the summer break, took advantage of my discount and hauled off to

87

Ireland with ten pairs of bra and panty sets that only I would ever see.

I have always liked lingerie, and I still buy it. Most of the time I am proud of what gets organized into those squares of lace and satin. It's taken me twenty years to get there. But each time I walk past a Victoria's Secret store, I feel a rioting in my body that goes from my stomach to my feet. I feel engaged in this conspiracy that women are supposed to look a special way – especially naked – and that, when faced with their own bodies, they should always look away.

When I see Frida's corsets encased behind class, I think of that girl in the dressing room talking with all of those women living in their intact bodies, and I think, if only I could get behind this glass with you, Frida. I would fit that corset tenderly against your spine. Or I would fit it over mine. I would feel the shudder of fabric over my head as I dressed you in the colorful robes of your dresses, and I would wear them too. I would carefully zip up the artificial boot with its wing about to take flight.

I would honor your body, even if I still struggle to honor mine.

– Los Angelitos –

At the museum in the birthplace of the artist Diego Rivera, in the city of Guanajuato, Mexico, the same place where his nude portrayal of Frida hangs, there is a gallery of portraits called *Los Angelitos*. The museum itself is like a stop-time photograph from a different age. Various rooms of the house are staged, although some are off limits, and visitors move through the available spaces as if moving through an imagined day in the life of a family whose furniture remains intact though its members are long dead: the bedroom with thick wooden furniture and canopied crib for a tiny Diego, surrounded by a braided cloth rope to ward off those who might be tempted to touch; the impressive entrance halls lined with art in gold frames; once-used dishes now stacked behind spotless glass. The only sounds are the shuffling of curious feet and muted voices in English, Spanish and German.

On the top floor of the house, in the upper rooms full of light, are the little angels, two white-walled galleries of carefully curated photographs of babies being held by parents, siblings, sole mothers and single fathers, all dressed in fancy clothes that are neatly pressed and seldom worn. In some of these family portraits, older children with dark wings of hair

over their eyes lean on one elbow over the baby, who is usually lying on a table or positioned in the arms of a solemn-looking parent. Solemnity was usual in the nineteenth-century photograph, so this does not surprise me. I look at the dark-haired families; I stare into the faces of the children, the parents, the babies.

Because my son Ronan was blind for a year before he died when he too was still a baby, it takes me a full twenty minutes of looking at the photographs to realize that the babies are dead and not just afflicted by the unique vulnerability of being a baby and having no choice but to rely on the goodness of others, of the world. I am used to the sight of the sightless after so many long hours singing into the face of a baby who would never see me fully, never know me apart from the animal instinct he was born with that told him I was his mother. I assumed they were baptismal photos. The father of the child I carry inside me has been walking silently behind me; when I turn around and see his face, I realize my mistake.

'Are they dead?' I ask him, as if they have just died and I am asking for confirmation. He nods. His eyes are dark and glittering.

'I thought they were being baptized.' The babies in the portraits mounted on the walls where Diego Rivera was born are wearing burial gowns that are frilly and white and as elaborate and delicate as baptismal gowns. Looking more closely I can see that the way the living person interacts with the camera is different from the

stillness of the babies. In death, even their bodies are mute, although it is those silent bodies that tell the whole story of every other person in the photograph. I feel dizzy with the bizarre meaning of time in this lit upper room: everyone in these photographs is dead, but in this isolated, unrepeatable, documented, mummified moment only the babies have marched forward out of measured time. Their blank eyes offer only a reflection of where they have gone, which is a place from which there is no return, no going back, an unknown to which we are all headed and about which there are no believable reports. Why can these babies not tell us what we need to know?

The room is suddenly loud with Ronan's voice, the way it faded and quickened in the minutes before he died and then stopped. The way it was always a collection of sounds that never shaped into words because there was a neuron path that had been burned to the ground of his brain and, smoldering and useless, became part of a decimated forest it would take a figure from a fairy-tale to heal or resurrect. A forest of personality and personhood that nobody – not even he, the inhabitor of it – would ever visit or know or recognize. I feel a surge through my body of something that is not grief or anger, but a necessary numbness that acts as a net through which I view the photos in the rest of the gallery. I am light-bodied and cold. I do not want to run out; I want to see these babies the way I did not want to see my son's face in the hours after he

died but did so anyway, lifting the embroidered shroud again and again: not wanting to see, wanting to see. His eyes would not stay closed although his body was heavy, so I closed them again and again, trailing the bitten edges of my nails through his long eyelashes. I was not weeping then, but choking and dreaming with disbelief, relief, release, alienation, attention. I would be left to tell his story and not the other way around. A fairy-tale grinding backward, a gruesome reverse. One day a leg, the next day it is no longer. One day a beloved, the next day no longer. One day a mother, the next day no longer. What kind of life is this for a body?

I descend from the top staircase of the museum, through the rooms of modern art and sculpture and out into the street where it has been raining for hours, slowly and lightly. Our clothes smell of the strong detergent used at the *lavanderia* where we have had them washed by a young mother whose three-month-old baby coos and kicks in the cot next to a long line of washing machines that spin and stop and whir at different intervals. He was fussy when we went to collect our clothes. His hair was thick and dark and straight. I put my finger on his forehead and he looked at me with his seeing eyes and then fussed a bit less. That I was able to comfort him flattened me, for what good is a mother whose child has died?

The week before I arrived in Mexico, I discovered in a drawer, stuffed in with receipts, underwear, and stray gym socks, a single red mitten that was Ronan's,

and the shirt that I cut from his body after his death, printed with rockets and planets arranged in a whimsical pattern like a dream of the beyond. I had been moving both items around in various drawers for months, always wondering what happened to the pants that went with the shirt I cut off. Where were the matching space pants? I never bothered to actually look for them, so I never found them. 'Ronan's not an angel,' I say all the time, to anyone who will listen. 'God doesn't have him.' Who does?

It is Christmas in Mexico, and all around this city with its winding, cobbled streets and ringing bells, we have watched people marching purposefully to cathedrals, holding their baby Jesus figures decked out in festive costume and plucked from the home crèche to be blessed by the priest. It is men who do this ritual shuttling of the doll, their precious, inanimate bundles wrapped in brightly colored blankets printed with the image of wide-eyed animated bears and Hello Kitty.

Dry leaves cross the Zocalo, the plazas, the polished holiday shoes of the living children headed to Mass or headed home.

Angels. Perhaps they exist in some other world, but it is not enough. Rebecca Solnit, in *The Faraway Nearby,* quotes Mary Shelley, author of *Frankenstein,* writing in her journal in March 1815 about the death of a child: 'Dreamt that my little baby came to life again – that it had only been cold and we rubbed it before the fire and it lived. Awoke and found no baby. I think

93

about the little thing all day.' The parents of the dead babies in the photographs in the Diego Rivera museum hold them as if they are alive, as if they are looking for a fire before which to rub them awake, their faces drawn with resignation and an unspoken ambition to solve the unsolvable. Sometimes I hold the plaster cast a friend made of Ronan's hand and pretend it is warm and real. I trace the creases in the palms and examine the white material of his fingernails for imagined dirt.

In the bakeries I select hot loaves of bread and glistening pastries with silver tongs and arrange them on a tray. Guanajuato is known as the haunted city because of the mummy museum. I deliberately avoid the mummies. I have heard some of them are actually not so old, which is somehow more horrible, and that they were given to the museum when their families didn't have money to bury them. A newer mummy seems scarier than one that has been dead for centuries. I know that the dead and the living are believed to co-exist here, walking side by side, but I want to walk next to my living son, if only he'd been able to walk.

At night, when the otherwise non-stop dance party on the roof next door to the rented house takes a brief hiatus and I am able to sleep, I have dreams in which Ronan is helpless in some foreign land. Someone is putting him on a plane, but they do not know how to care for him, how to support his head, how to feed him, and he will die. People want to hurt

him, but I don't understand why, and this makes me murderous. People are trying to blind him with acid although he is already blind. They want to hurt him, cross every boundary of cruelty and, in my dreams, I try to kill them with my hands, bombs, knives, rockets, words, anything that can be fashioned or shaped into a weapon. I wake up frightened: by my rage, by a feeling of impotence that is the loss of love. I thrash around, slobber and pant, and cannot be coaxed back to sleep. I listen to the music next door. I think, suddenly, *I should get up and dance*, but I lie still and think of the portraits of dead babies, *los angelitos*.

The sounds of the techno music and shouts of the living mix with the imagined voices of the unnamed dead babies, who leap from their portraits and form a circle on the floor of the well-lit upper gallery in the home of the dead artist, in a country where skeletons walk with the living in artwork and lie half-buried in the ground, and inside the circle sits my son, telling a story of what we need to know, although nobody can stay awake or asleep long enough to hear what he is saying. Only the babies cheer him on with their language of coos and kicks and hiccups; beholden to no one, they say only what they want to hear. Ronan keeps turning the pages of a book that nobody else can read, his own story, the story of ordinary babies and ordinary time, and the people who are left behind to mourn both.

– The Cripplied Body (II) –

Pain, in the eyes of others; suffering, in the eyes of others, can make you into a hero.

As I was boarding a flight, the gate steward watched me approach the entrance to the jet way, scanned my boarding pass, looked me in the eyes and said, 'Thank you for your service.' Confused, I mumbled, 'You're welcome.'

During the flight, the stewards seemed unusually solicitous. 'Don't you have to pay for these now?' I asked a very friendly steward who brought me a blanket. 'After the whole SARS thing?'

'Oh, don't worry,' she said, as the pre-recorded safety video reminded the passengers not to *tamper with, disable, or destroy.* Every five seconds I was asked if I could be made more comfortable, the flight crew doing everything short of offering me a free glass of chardonnay at ten in the morning.

As the plane landed, an announcement was made over the loudspeakers – not the captain speaking gibberish about the flight plan and weather at our final destination, but a message that could be clearly understood: 'We'd like to give a round of applause to the veterans who've served our country and are flying with us today.' Remarkably, the friendliest

steward looked at me, and any passengers who were not plugged into their handheld electronics vigorously applauded, many of them in my direction. Mortified, I realized that the flight crew – and quite possibly a plane full of strangers – believed me to be a member of the armed services. A quick scan of the seats around me yielded nobody in army fatigues or uniforms or other distinguishing clothing. I had been at the gate for nearly an hour, waiting to board, eating a hamburger, watching a football game, people watching. Had I missed something?

I am not a veteran of any war. What I know of combat and wartime conflict has been learned from staged confrontations on a movie set or stylized explosions designed in a special effects studio, from films like *Saving Private Ryan* and *Platoon*; the one long, dark semester at college when I took a course about the Holocaust and briefly considered declaring a history major; and hazy memories of a high school history class taught by a lecherous middle-aged man who constantly made public comparisons between my red hair and the fur of his beloved golden retrievers.

The prosthetist who made my legs from 1978 to 1987 was a veteran of World War II and the Korean War. His bald head was covered in brown spots, one of which was shaped like the state of Florida. He wore a filthy apron and steel-toed cowboy boots. His office was behind a used car lot in Denver. In the back room, while he ground away at the wooden calf of my leg, he

smoked cigars and I sat on the table in my underwear, watching him, flipping through the pages of a *LIFE* magazine from ten years earlier with stains on the cover and yellowed, curling pages. A motley collection of rubber and foam feet and shiny wooden legs hung from the ceiling on straps, swinging in rhythmic patterns under the air of a single, circulating fan perched on a step stool near the bathroom that smelled of cigarettes (a few butts were always floating in the toilet) and Clorox. Rather than relinquish his cigar to ask me a question, my prosthetist bit down on it and spoke to me through clenched teeth. I adored him. Apart from me, his patients were all veterans of the Vietnam War who, I recall, started a lot of sentences, with 'hey man', and called me 'little missy' or 'girlie'.

Times – and prosthetics – have changed in the three intervening decades. My current prosthetist, and the one who has made my legs for the past twenty-four years, operates in a clean and efficient office. I am referred to as a 'client', and often when I'm in the office I'll see a young man or woman wearing fatigues, testing out their new prosthetic in one of the practice rooms. As the wars have gone on, women have joined the ranks of veterans I meet at the office, and now, in my forties, I'm often more than a decade older than some of them. The technology that makes my life easier and my prosthetics more advanced has concomitantly improved. The leg I currently own features many technological bells and whistles that would have been

prohibitively expensive for someone without veteran status even five years ago. Access, then, to advanced prosthetics, is directly related to our country's involvement in warfare. Modern war = modern limbs. The ethical equation here is a troubling one, of course, and, apart from the very nuanced discussions such a cause-and-effect chain necessarily evokes, the advancement of prosthetics has also changed the view and status of people with disabilities in this country and around the world.

Or has it?

Another airport anecdote: each time I fly, I must be body checked by an agent of the Transportation Security Administration, my hands and leg swiped for explosive residue. Without fail, I hear a version of the following: 'Wow, I never would have known about your leg.' 'You sure can't tell.' 'I've never met someone like you before', or 'You're so brave.' If I had *not* been wearing my artificial limb and had, say, hopped through security or used crutches, I can imagine the stares, the very different treatment I would receive. My experiences at public pools have taught me that the look given to an obviously disabled person is a mixture of pity and wonder. Because I am able to 'pass' or keep my disability largely hidden, in part due to the quality of the limbs, I am deemed acceptable; or, better yet, brave.

The assignment of bravery to someone who is simply getting on a flight and happens to have a disability

is mystifying to me, although not unprecedented. Sociologist Rebecca Chopp coined the term 'Super Crip' to denote the kinds of stories about people with disabilities that make non-disabled people (or the temporarily able-bodied, which is much more accurate) comfortable, in part because they represent such polarizing experience that the non-disabled person feels safe from any thoughts that they might someday become disabled themselves. Stories about disabled athletes are 'inspirational'. Stories about forty-something amputee writers with a kid and a job as a professor? Maybe not so super. Maybe not the kind of narrative people want to hear about disability. People crave stories about people who triumph, who 'overcome' their disability, but this, too, is a false expectation. I have a disability. Does it rule my life? No. But does it deeply affect my life, particularly as a woman and in the way in which I relate to my body? Every single day. There is no glitter here. Pain is not a baptism into genius.

The overcomer narrative is so popular, in part, because the flip side of it feels outdated, although it exists as well. This is the well-worn story of disabled people as the objects of pity, or as the embodiment of everybody's worst fear.

Why should it matter if you can't tell when someone is disabled? Frida, like me, was practiced at the art of hide and reveal. Her most elaborate outfits – the legs with wings, the corsets decorated and embroidered with flowers and birds and about to

take flight – all were kept under wraps. Even as more and more people return from war with amputations, men and women of all ages and from all walks of military life, our corresponding notions of physical 'wholeness' have not changed much, and a 'normal' body is somehow considered equivalent with ability. I am an athlete: I like to run, do yoga, cycle, lift weights. Does this make me brave or incredible? Not really. It makes me an attentive steward of my body, its primary caretaker. What it *does* mean is that because my country has engaged in wars, I am able to participate in these activities with greater ease and success than ever before. Perhaps it means that people are more comfortable with the face of war than with the fact of disability.

When Desert Storm appeared like a spectacle on television, I was a sophomore in high school, and in charge of editing the world events section of the high school yearbook. I lived in a small prairie town in Nebraska, where people were more concerned with what was happening on the most recent episode of *The Simpsons* than they were with politics or world events. All of our stories came from the AP news wire, stories and pictures that we cut and pasted into the middle section of the yearbook. But when the bombs started dropping and we watched the 'show' on television, things changed. 'If they bring back the draft,' my brother told me, calling from his dorm room in Minnesota, his voice high and light with fear, 'I'm going to

Canada.' Boys in my school had been planning to join the military to pay for college; now they were facing a war. 'Maybe I'll come back like you,' one of the boys in my class said to me once. 'Like with a wooden leg and everything. But I hope not.' I stood, dumbfounded, at my locker.

The Gulf War was the first war I would remember, although not the last. In 1990, my leg was a wooden relic from wars past, and made of the same materials and with the same rudimentary function as Frida's leg made nearly forty years earlier.

In 1992, I finally had a hydraulic knee and a new attachment system that would have been inaccessible to me without the Gulf War that my generation watched unfold on television. I never thought I would be mistaken for someone who had done more than watch. My body, however, was complicit by its very ability to move through the world, a by-product of war and its damages.

Disability makes people uncomfortable, in part because it points to the chaos of the world that we know to be true and try to ignore; namely, that we will all someday live with a disability of some kind. I understand. Frida understood. That the rhetoric around disability needs to change to adapt to the changing face of disability is obvious; the question is: will it?

– Dear Dr Frankenstein –

I'm not allowed to write much, but this is just to let you
know that I'm already over *the big* operation. It's been *three*
weeks since they cut and cut bones. The doctors are so
marvelous and my *body* so full of vitality that today they had
me stand on my own poor *feet* for minutes . . . Later, they cut
a piece of my pelvis to use as an implant in my spine. This is
the scar that is the least ugly and most straight. Five verte-
brae were damaged, but now they are going to be fine.
– Frida Kahlo writing to Alejandro Gomez Arias
from New York City, June 30, 1946

I have worn a machine since the time I learned to
walk. Made of disparate parts, I have, like Franken-
stein's monster, moved as a hybrid person through the
world, an amalgamation of mechanical parts that ena-
ble me to live and thrive. Unlike Frida, I can't sew or
stitch or draw or knit or embroider or paint. My legs are
not decorated objects of art. My child will never have
homemade Halloween gifts or hand-knitted sweaters.
And yet Frida hid, and I do not. But what if in the act
of hiding there is the simultaneous act of reveal?

I began my toddler life in a metal brace secured to
the body by Velcro straps and a foam bump under the
left foot that made my legs even, or 'line up' as we said
('Is it lined up? Do you feel lined up?' the brace out-

fitter asked) for the purposes of learning to walk and then walking. For years, whenever I had an art assignment in school, I would look at the lines on my drawing and think of the lines of the body and how both were meant to be even, solved, symmetrical. That sketch of Frida before her amputation – all the muscles and bones in the right place. This brace I wore was a primitive machine, all metal and easily soiled cloth and clickety-clanking noise, a literal cage for the smaller leg that kept it straight and able to swing through after the right leg, the lead leg took a step forward. *One step, two step, three step.* The moving dance of the unevenly constructed.

After the amputation and subsequent modification operations I graduated to an equally primitive machine-leg that was made of a light pine the color of the cabinets in my childhood kitchen. This wooden shell fit over my residual limb and attached with a cloth waist belt that frayed at the edges and rubbed against my hips when I walked, often creating rashes and sores that my mom rubbed with ointment. Secured along the sides, like two metal eyes, were the hinges that swung the leg through to its next-step destination. My dad had hung a rope swing in our garage, and I loved to swing, charging the right leg forward and then watching the bottom half of the left leg swing through on its own, back and forth, like a door closing shut against the body, both a part of me and also separate from me, mindless in the way that inanimate objects are subject to gravity. I accepted this body as mine, and at night I

tore off the simple machine and let it rest next to my bed, an off-body talisman that, in the morning, like some kind of strange modern fairy-tale, would be reintegrated – although not always easily – into the shame-free body. Helpless without it, the body was suddenly made active and mobile with the presence and assistance of this human-made device.

Ronan stood up on his own only once, with the assistance of a therapeutic suit called the Thera-Tog, a full body ace bandage meant to support and elongate his spine and enable him to stand on his feet, which were already starting to become locked in a pointed, painful position from misuse. We positioned him next to the coffee table, wrapped in his beige space suit and, for one second, he lifted his palms from the table and stood, just for the smallest moment, before falling back into the physical therapist's arms. The look on his face communicated all the joy and freedom of the body that he would experience in his short life. I used to cry myself to sleep at night, remembering the way his eyes lit up, that first and last time he stood unassisted; a wrenching moment, but at least he had that moment and I had the memory of it.

*

As a child I imagined my body was put together by elves who would beaver away in back rooms coated in sawdust, dirt, and metal parts. I was the small girl version of Frankenstein, weirdly made but heartier and

stronger than I looked, full of both power and sadness. Initially, as a child, I took great pride in being distinctive. In those days, the early 1980s, before the United States entered more wars from which men (and then women) would return in need of reconstructed body parts, the amputees I encountered were Vietnam vets. They too, were disabled, although the circumstances of them becoming so were far different from mine.

The prosthetist's office in Denver was located on the nondescript corner of a rundown block in a sketchy neighborhood, the floors dirty and coated in dust, the rickety wooden side tables in the waiting room littered with old magazines. The traffic moving by on Colfax Avenue was often barely visible through the windows, which were blackened by decades of soot and grime. As an adult I would look back and think of this office – of its waiting room and back room and walking runway where we tested the adjustments to the leg – as a place where machines of shame were manufactured; machines for the incompletes, the outcasts, the abnormal, the 'disabled' as we were then and are still called, as if we constitute some shapeless barbarian horde. As a child, however, I filled that dust-filled space with my constant chatter and genuine curiosity. 'What kind of leg do you have?' I liked to ask the other amputees, and these men, these war veterans – who seemed to me ancient and slightly edgy, with their smell of cigarette smoke and sleeve tattoos – would chat to me about which legs they had, their ailments, their various aches

and pains. We were the definition, I thought later when I first heard the term, of the walking wounded. In another century or another country or another time we might be made beggars or literal outcasts, so we converged here, at this place where machines were made, to collect the mechanical parts that would make us mobile and animate and at least partially human.

As much as this early machine mobilized and enabled my life, it often failed me as well. Prosthetists were unaccustomed to constructing these body machines for girls, and the height of my leg was often wrong, the fit made for a man, not an underweight little girl. I was literally mismatched and asymmetrical, the one side slightly withered and incomplete. Slowly, as I graduated up through a succession of wooden legs, my feelings of distinctiveness gave way to feelings of shame. The difference I embodied was not a mark of being special; it was the signal of a mobile freak show. What did it mean that my body was made by another? It made it less mine, and it also made me less accountable to it: I could abuse it, berate it, starve it, hate it. All of which I eventually did.

During one long, hot day of summer adjustments in the Denver office just before I entered puberty, I hopped to the back room to have a look at what my prosthetist (we called him a doctor although he had never gone to medical school), was doing with my leg, this precious and expensive machine. I stood in the doorway in my underwear, leaning against the

doorframe, and watched my leg move back and forth beneath a saw that descended from the ceiling, roaring and raging, spinning angrily and preparing to cut, slice, devour, change. Flecks of wood flew like sparks and floated through the air; flake-shaped particles, atoms of artificial wood-skin. How strange to be divided from a part of the body, to see it manipulated in the hands of another, treated, sawed, handled. I felt sick to my stomach, queasy and unsettled. Without this machine that was being transformed beneath another's hands I had no power, no mobility, no chance of being in the world in a way that was significant or, I felt, meaningful. I stood there for a long time, watching the 'doctor' do his work on my body that was also not my body. A cigarette hung from his lips and bits of bright ash flickered on the table. He cursed at the leg, tugged at it. I ached for the leg. I hated it. I wanted to pluck it from beneath the whirring blades of the saw. I wanted it to be chewed up, incinerated or disposed of once and for all. I hated myself. I was a monster, I thought, and felt monstrous as a result.

I was uncharacteristically quiet on the way home. 'What's wrong?' my dad asked.

'Nothing,' I said, but what I meant was *everything*.

At night I began storing the leg in the closet and shutting the door so I wouldn't have to look at it or know it was there. I lay in bed and imagined a new leg, all glorious flesh and blood, growing in the empty space beneath the covers. I would awaken transformed.

Reliance on a machine made the hormonally charged heart and growing mind of a teenage girl spin: to wear the machine, to rely on it so deeply, was to be bound and shackled but also free.

'I hate you,' I once said out loud in the morning as I was putting the leg on. I meant the leg; I meant my body. My brother was walking past my bedroom door. 'Who are you talking to?' he asked. 'You,' I said, and slammed the door in his face. I did not talk about the leg and nobody knew how I felt about needing it. I covered it with questionable fashion choices from the eighties and tried to put it out of my mind.

In high school I prayed to be healed from my machine, to be rid of it, although the idea of being parted from it filled me with a great and terrible dread that felt to me like the knowledge of death. It would be like jumping off a building to be without it. At slumber parties I clutched it to me in the sleeping bag. At high school parties I was careful to hide as much of it as I could, to shroud the difference in long pants or thick tights. I hated the object I most relied on to move, to live, to belong.

Over the years my relationship with this machine has changed with technology. I have left one leg after another as I grew and technology advanced. Limbs now have knees that operate like computers; feet come with intense shock absorbers that allow people to run and leap and compete in competitive sports; I own a running leg and a leg with an adjustable foot made

to wear with high heels. But this relationship with the mechanized body has always been contentious, because a woman's body is, in part, her currency in the world, however we might try to deny it. A woman is embodied, and she is judged accordingly. We want to think that we are beyond this, that we are more than our bodies, but, in the end, we are not. We are both easily reduced to the sum of our parts, but sometimes we are reduced only to our parts. As a woman who wears a permanent machine, I still feel this acutely.

At my high school graduation, dressing in my room with another amputee girlfriend of mine who was visiting from New York, I looked in the mirror and said, 'it would just be so much better with two real legs', and she agreed. The 'it' of the body was the crucial point. We wanted to be pretty, to have our bodies be acceptable, normal, and noticeable but in a way that felt special, not strange, and we carefully calculated the fine line between these two descriptors. We didn't want to select a flesh-colored hose that matched the flesh-colored paint of the legs we wore, both of which hardly matched our own skin tones. We didn't want the leg to make loud noises as we walked. We didn't want to be stared at. We wanted to be women without a reliance on machines. We wanted to be whole without assistance.

Sex presented a particular dilemma. What to do with the leg? How to explain it? I worked to hide it, believing that the vulnerability of difference

was not sexy, or special. During those early years of sexual activity I felt a deep embarrassment coupled with a furious wildness – a feeling that I needed to overcompensate, prove that I was worthy, prove that I could be chosen in such a state, and that a so-called normal person would pluck me from the freak show, make me belong to a different group of people, the 'right' group of people, the beautiful ones.

*

When I became a mother, my relationship to the body changed. A different kind of internal machines – all mysterious organs and natural processes – had been activated inside me, and everything worked perfectly. I made a beautiful boy, perfectly made, it seemed. But at nine months old he was diagnosed with a terminal ill-ness – a progressive neurological disease – that would claim his life before the age of three.

At first, I irrationally blamed the hybrid body with its leg machine for what was happening to my son. And I blamed myself as well. How dare I think I might actually manage to build something perfect in this body that had to be helped along by expensive, man-made parts manipulated by the hands of men. But as my son's condition worsened, I developed a more nuanced relationship not only with my leg – which seemed an easy problem compared to his many ailments – but with the machines that also contributed, for a brief time, to his well-being and quality of life.

Because Ronan had trouble swallowing and sometimes breathing, he used a suction machine and an oxygen machine. At the end of his life he used a nose tube that distributed pain medication. Nothing about his body in the world was easy and, suddenly, all the mechanical parts of my brain that worked together to enable me to speak, walk, type, move, shout, eat – all of it – seemed miraculous. I cursed myself for thinking that I was monstrous, that difference could be so easily understood or misunderstood. *Everything* was wrong with my son, and yet he was perfect and singular. He was my creation, but I would never, as Dr Frankenstein had, leave him. My love for him remains a burden I will never put down.

Frida lost three children either through miscarriage or surgical abortion; her bone grafts became infected, her kidneys inflamed; her hands covered in fungus; her appendix removed. Still, she painted. Ronan's body betrayed him at every turn while I looked on, my heart in my mouth. Still, I wrote.

I speak to Frida across time as she speaks to me, as she speaks to all bodies who have felt outcast or less than, bodies that have disappeared. This line from a 1930 letter to her father:

> Write to me
> everything you do
> and everything that happens to you.

– Letter from Spain –

Me falta tiempo para celebrar tus cabellos.
[I don't have time enough to celebrate your hair.]
– Pablo Neruda, Sonnet XIV from *100 Love Sonnets*

Fundacion Valparaiso, Mojacar, Almeria, Spain
June – 2011

Dear —

I am at my great wooden slab of a writing desk in paradise, looking out over a hump of mountain crowned with lights, and I don't know where to begin, so I don't know where to end and I don't want to end or begin or figure out which is which and why or how. Today, dropping through the thick layer of clouds, a hoop skirt of sunshine opened like the bones of a parasol but offered no shade. Tonight is summer solstice. A change in season. There will be a bonfire on the beach and free sardines *(gran sardinada!)*, live music and booze and treats for kids. Noche de San Juan. *Equinocio* – the equinox. People will throw what they want to cast off into the fire, little sins or sadnesses scribbled onto slips of paper and scooped up in the blaze. I have nothing to burn and everything to lose. I am not in the mood for fiestas. I'd like to avoid all ritual. I don't want to sip the ocean air or feel sand scratch between my toes. I want time to stop. Flames, stop. Water, stop.

Sun and moon and stars, just quit it. Carefully crafted narrative finally fractures, which means that what is today is no longer tomorrow but yesterday. What is behind is already in front or perhaps to the side or underneath or nowhere at all. Dates blend. Nothing belongs to no place and lives inside no body.

*

Kafka said:
'[W]riting a letter is actually an intercourse with ghosts and by no means just with the ghost of the addressee but also with one's own ghost, which secretly evolves inside the letter one is writing or even in a whole series of letters, where one letter corroborates another and can refer to it as witness.'

*

Walking into the pueblo of Mojacar a dog trots past with a fly attached to his nose; he tries, in vain, to shake it off and eat it. It flies up and lands, flies up and lands. This requires his full attention and makes him too hot to bark. 'Are you one of those dogs that barks all night?' I ask. He bites the air. If I could catch the fly, I'd feed it to him. A thumbprint of gray is pressed to the end of his nose, like an accident of paint, a tiny flag of age waiting to flutter further and faster up his face. 'Perro?' I ask the Spanish dog, trying to recall the lesson about animals from high school Spanish class. *Yo me llamo Emilia* is all I get. *Hace much calor.*

Hola! Wind lifts the dust from the road; it swirls in eddies behind me as if I'm being followed. Not by the dog, he has disappeared behind the gate. The staccato chatter of crickets is interrupted by a little van moving down the road that is cut into the soft mountain, a finger sliding carefully through a mound of frosting so nobody will know that the cake has been plundered before the party begins, before the candles are pushed in and lit. *Babies with Tay-Sachs don't live to be three,* I hear the doctor say. The van is a child's toy and it blurts a message from a single crackling loudspeaker: *uno nino cinco anos.* Two hours later, walking in the other direction, the same van going the other way, bearing the same message: *uno nino cinco anos.* I know the translation (a five-year-old child), but what does it mean? I am afraid to ask the question.

*

In the place where I am writing, in a farmhouse where ten artists work in ten rooms, there is only one phone box in the hallway outside the kitchen. If I call home and my child is eating lunch, I will cry and everyone will hear me and if he is not eating lunch I will also cry and Ronan, I have a song for you.

*

Today, 5,000 miles away, Ronan is alive. My son, on this day, is alive. I am reading Kafka. I cannot sleep. I cannot imagine living beyond him; I cannot imagine

his death, and yet it is all I can think about, the how and the when.

*

In April 1920, Kafka wrote to Milena Jesenska: 'It occurs to me that I really can't remember your face in any precise detail. Only the way you walked away through the tables in the café, your figure, your dress, that I still see.' This was a P.S. He loved her.

*

The evil eye cannot find you during siesta. Your eyes are closed, and it is forced to find someone who is awake, this stupid, nasty, roving, stinky, old dripping eye, I fear you. The wind relays softly through the trees like a skinny, fragrant monkey. The day dozes and drops its head. I need a witch to poke the eye out with a witch stick. People who run into fires are not brave; they have no other choice, and you do not know which person you are until you're standing in front of the flames.

*

Milena's letters to Kafka did not survive fire and censor. She walks, voiceless, through his mind and his memory, but he answers still.

*

The streets of Mojacar are twisted; it helps the wind

move more efficiently, cooling streets, tempers, dogs, and now tourists from northern Europe. I hear the goats now (*cabritas!*), their tiny goat bells softly tinkling the way they would talk if they had words instead of weary bleats. Every hour, on the hour, the bells ring out from some unseen cathedral. 10-9-8-7-6-5-4-3-2-1 seconds later another cathedral telling a different time rings out the 'new' new hour. Which one is the real one? Which time is the real time? What is time for the actively dying?

*

'It couldn't look better,' the doctor said after the final ultrasound, all those tests.

*

Fireworks explode over the hills outside my window, over the empty luxury hotel full of abandoned furniture and half-built rooms. A limp and distant *pop boom*. People and lizards are living in the hills. A man runs into a shop to buy bread at the 'crisis' price of one euro; it is a crisis, it says so on the bag. A dog stops barking. A baby sleeps. A door slams in the wind. An empty drawing table sits on a sun-drenched porch. Someone says, 'I want to talk to you' in Spanish behind a screen door. 'Urgent,' they say. The bells are ringing. The sound stuck.

*

People ask me: 'How long does your son have to live?' Usually, I say nothing.

*

I forage for food at night in the kitchen when everyone is asleep.

*

Kafka was an insomniac. Writing to Max Brod he wrote: 'After a series of dreams, I had this one: A child wearing a little shirt was sitting to my left (I couldn't remember whether it was my own child or not, but this did not bother me).' Not a little child, but a little shirt. He could not sleep. 'Heavy pains in my heart,' he wrote.

*

My son has been dying for a year and I have not slept, on this August afternoon in 2011, for about five days. I have many important things to say, weird energy that explodes into images, ideas, poems, whole chapters that spool out of my head as if I could roll the ideas across the long stretch of wood floor in the room that is mine for two weeks. I am scribbling on napkins, paper coffee cups, books that are not my own and that will be reshelved in the residency library with my manic notes scribbled inside. I feel no shame about this; I just cannot stop writing. This need outweighs any other – sleep, food, conversation. I do jumping jacks for an

hour and sprint from one end of the room to the other. I take Xanax and drink glass after glass of homemade red wine that arrives in a half-carafe outside my door each evening after dinner. I still can't sleep. My brain is splitting open; my body is on fire. I am becoming someone else, just as I've always wanted, but not like this. The cost is too high.

I should be at home, I think, staring at my son and making the most of every moment I have left with him, but instead I am hypomanic in an old farmhouse near Mojacar, a white, hilltop city near Almeria in southern Spain. The days are hideously hot, and the nights marginally better with the cross-breeze moving through the room. I read Kafka's letters; I read stacks of poetry books; I write until my fingers tremble and cramp. I wander the stretch of dirt road in front of the farmhouse, singing arias to myself. None of this is normal, and I know it. I call my best friend Emily in London and tell her I'm losing my mind. I call from the single phone box, dropping euros into the slot, my voice – even at a whisper – echoing through the kitchen. I ask her to come to Spain because I am frightened. 'Help me,' I say, the moment she picks up.

She comes to Spain and she helps me. When she sees me walking toward her on the road the next morning, she takes me directly to her air-conditioned hotel room where she watches me sleep for eight hours. In the afternoon we drink wine and smoke cigarettes and drive along the coast listening to American

country music, her favorite. 'Look after yourself,' she says when she leaves, tears in her eyes.

The night Emily returns to London and I feel more like myself again, I sit outside with Amir, an Israeli poet who is also a resident. He is direct and argumentative, which I appreciate. We are looking at one of the art installations left behind by a visual artist. A tree shaped in the likeness of Jesus is perched at the highest part of the highest hill in the near distance. Just below, a motorway buzzes with traffic. 'It's kind of weird to see Jesus hanging from an actual tree that isn't shaped like a cross. Or is he standing?' Amir lives in Jerusalem. He knows his crosses. 'I guess that makes it art,' I say, and wonder if that's true.

*

Far away my baby is still alive, his life a swiftly departing dream. The bells ring out on the unseen hill. Cars curve around the mountains, another finger tracing the sweet road, another long, shallow dent. Mojacar dogs bark all night. Spanish poodles patrol the mountainside terraces, teeth bared and tails wagging.

*

In Germany the news reports that in Almeria, Spain, the place I am writing from, 'the cucumbers are rotten with disease and not even good for goats', but we ate them. 'Cucumber psychosis!' the newscasters said, but the women kept coming, each day, to cook our meals

in ceramic pots the color of earth and wash our clothes and scrub bright coins of blood from my underwear. All day long doors and windows slam shut beneath me. The house is full of empty rooms. Green bugs with intricate Elizabethan wings fight roughneck flies on the windowsill and win. A spider the size of my palm runs across the roof as if to say *Good luck!*

*

Simone Weil was right: 'When a contradiction is impossible to resolve except by a lie, then we know it is really a door.' What I write is a door.

*

The bells bring in the animals, but not all of them. Some were burned in the farmhouse fire: goats and also horses, who were trapped in their barns. Thousands of almond trees and olives. I imagine a hillside of burning oil and also the screams.

*

Bliss, see also *euphoria, happiness, joy.* Summer has arrived. The trees wear soft lace undergarments of spiders' webs, and I am missing you. My room is a long corridor of wind. At night I leave the key inside the lock, just in case. I will do this for the rest of my life. A small key under the mat, under a plant, just in case the veil between this world and whatever is beyond it thins and you are able to return to me.

– The Temporary Mother –

My baby is asleep, and I am reading student manuscripts in the back room of my house in New Mexico. Outside, the winter night is clear and cold, the sky a fierce and stupid blue, my neighbor's wall a cliff of white that feels like a premonition. A faux fire clicks, smelling faintly of gas instead of wood, in the suburban stove. I work on a dark wooden desk given to me by a friend. I work out on an elliptical machine, lift weights, and do yoga. In the middle of the night, when I wake to check on my son Ronan, I sometimes run in place in front of the fire until sweat pools in front of me and drips from my arms and my forehead. I do it sometimes for a full hour, weeping, worried about staying awake, worried about the quality and endurance of my vigilance. I am the mother, and I practically live back here. The baby monitor hums and crackles, but the baby does not stir. He is at peace while he sleeps. It all feels so normal. This evening, after Ronan had his bottle and I tucked him in, I took a hot bath with a good novel written by a good friend and cup after cup of herbal tea. I can almost convince myself that there will be no split, no division, no end to this domestic snapshot. Maybe tomorrow the sky will just be blue, the wall just a wall, the fire in the stove nothing to worry about.

But, of course, there is plenty to worry about because Ronan is dying. He is almost three years old but will not reach that birthday milestone, or any other milestone. The truth is I can't bear to look at the milestone charts. The doctors speculate that 'it', meaning his death, will be respiratory-related. 'Pneumonia can be a sick child's friend,' the doctor says, and it takes me a few long minutes to understand what he has said; my son so sick that drowning in his own secretions might be the merciful way to go.

Ronan's lungs rattle and, when I put my hand on his back, which I do at least every hour during the night, padding across the hall in my bare feet, padding back, sometimes numb, sometimes weeping, sometimes trembling from the jumping jacks, sometimes slightly drunk, I can feel them vibrate. Any day could be the day. My son cannot see or respond or move, but he can hear, and so I talk to him through the long, quiet hours we spend together in this sunny house I do not own. I sing. When he has seizures that his medication cannot control, I babble and make up silly songs about his pooping habits and his hair. I think about being pregnant, his tiny foot kicking me in the ribs, the splitting of my stomach muscles to accommodate his movements – volitional then, non-existent now. 'Does the stinky baby want a bath?' I say, but his breath smells like sweet butter. I like the tasks of this calm and efficient motherhood: laundry in, laundry out, dishes shifting in the washer, the satis-

fying thumps and hisses and beeps of necessary things getting done. Normal. Habitual and routine. Slightly boring. What I expected would be a large part of being a mother.

Every week the hospice nurse assigned to our family rocks up to our house in her bright clothes and sparkling eye shadow and practical if occasionally heavy-handed kindness. She checks Ronan's heartbeat, takes his pulse, talks to him. He sighs, his singular method of communication, a low breath, a close-to-the-ground sound, as primal as a howl, only soft. On one particular day, after we situate him in his high-chair, she pulls out a neon yellow folder fixed with a large white sticker printed with the 24-hour emergency number. 'You can call anytime,' she reminds me. I nod. From this folder, one by one, she hands me sheets of paper, as if I am buying a house or choosing the level of insurance coverage on a rental car. My eyes water, the world blurs; each page brings with it an unanswerable question.

What will you do with the body?

Who is available to pronounce death?

How many hours do you think you'd like to have the body before it is removed?

Now that you are using an oxygen machine, please post this in your front room window: NO SMOKING ALLOWED.

This is the paperwork of dying. My son is entering the last stages of his life, a life that has been primarily

one of suffering, although he has been surrounded by love. *He will have known love for all his life,* people tell me, and I also repeat this to people – friends, family, occasional strangers. What I would like to say is *I don't know shit, and neither do you. Ronan doesn't know who I am.* But this sounds bitter and mean, and I am careful to keep these feelings to myself as much as I can. I sign my name, I write, 'mother', and dream of escaping to my back room as soon as the nurse shuts the front door behind her.

I read in the back room with the switch-on fireplace and the wide, dark desk because it is literally the last room of the house; it's full of symbols and signs of my new life, the life I hope to launch into when Ronan is gone: new relationship, continued fitness commitments, new furniture. Sometimes I feel like Ronan will die and I will walk through the back wall as if it never existed, sheer and wild as any phantom, or punch through it with some momentary superpowers granted by grief, that looming and malevolent giver. All the roofs of all the houses on the street will lift, and I will scream, I'm sure. I am preparing for this – the letting loose. The front room is the scene of endless conversations with my child's father, fights, a decision to separate and then split for good. He lives in that room, moving between it and the nursery when he comes to care for our son. When I find him in my back room, it makes me angry, but I do not say anything because we are still trying to have an amicable divorce. There are

still a lot of papers to sign. Perhaps it holds the fragile kindnesses between us, perhaps not.

When I still loved Ronan's father, we joked about being paranoid, worried about the safety of our first baby, worried someone would break through the window near his crib and steal him, some shadowy, bearded figure from an old folk tale spiriting him away while we slept in the next room.

Tay-Sachs is not of a folktale but of older, darker tales, war stories, this disease like a medieval terrorist, torturing in the dark, unmaking him in a cave that appears on no aerial or geographical maps, no maps at all. This is a disease of another time, and yet I am like a mother of any other time, of every time, desperate to save my child, but with the full knowledge that I cannot. He is 'wasting', as the professionals call it, and at night, when I bring him into bed, I trace the brittle bones of his back. Sometimes I barricade him with pillows because I am afraid of breaking his already broken body. He is preparing to leave me, I, who should someday leave him. In fifty years, I want him to call the person he loves best – a lover, a friend – and say, 'My mom died. She dropped dead.' Or 'My mom was hit by a bus, which is how she always wanted to go out.' That is not how it will go. This is the great unfairness, that what is done cannot be undone, and, in the morning, I crawl into the world and hate it, but also find remarkable beauty everywhere, in a tiny yellow leaf, singular and only, flying through a muddled sky

to land and stick on a rain-soaked window. Finding the beauty – this, too, is part of being a mother.

I breathe over Ronan like some hopeless, helpless guardian. Moving from the back of the house to the front takes you past the smooth green oxygen tanks, the oxygen machine itself that bucks and hums like a failing car engine, the suction machine with its dangling nozzle, the nebulizer with the tiny pink tubes of saline stacked beside it. When I put the oxygen mask on Ronan, his breath is visible inside the clear rubber; he is a tiny dragon puffing smoke, an astronaut nervous before first flight. There is a cabinet full of seizure medication and morphine, already, for those final moments. We have decided on 'comfort care' versus interventions, but the machines look dangerous and weird; I have trouble using them, too tentative, unsure of all the tubes and gadgets. I have never been good with gear. My hands are no good with careful movements. The last time I was on a plane I wondered how the history of flight has changed our notions of heaven, about where people go when they die. Our ancestors did not get up to 30,000 feet, and some of mine never left the rural counties where they were born. Where has all this progress gotten us? I wonder as I take inventory of these machines designed to help my son die of a medieval disease. I obsess about where he will go when he dies.

As a mother, people say, and then usually say something stupid or clichéd, as if being a mother

qualifies a dorky sentiment about life or the passage of time.

I care about making a good impression for the hospice nurses. I want to be a good mother, even though I cannot protect my child, the one thing I am meant to do. I offer them tea, cookies, rings of soft and sticky Danish that I cut carefully from the enormous pastry slab that arrives each week from a friend in California.

'As a mother,' the hospice nurse says, 'it is up to you'. I nod. 'It's up to me,' I repeat back to the nurse when she says that these decisions about my son's life and death are mine to make. I am alive, lit, and grieving. I am a 2,000-year-old teenager. 'Sign here,' she says gently, but matter-of-factly. She is not leaving the house today without these signed forms. 'He's a beautiful boy,' she says. 'Yes'. In the morning when I turn to look at Ronan, snuggled next to me in bed, there is a fine white dust on his nose. He smells like milk and baby oil and toast. His dark blond hair is soft and spread out on the pillow like a merman. His sightless eyes are ringed by girlishly long eyelashes; he blinks at me and coos. His warm hand on my belly, where I position him nightly, is the smallest miracle; my arm tracing his spine is a sensation I work to memorize.

A friend tells me that once you have a child, the cells of that child never leave your body. But this is useless to me, I explain, because I cannot regrow

Ronan's body, we cannot clone the ones we love, and no scientist has discovered how to shoot into his brain the single stupid enzyme that would save his life.

I do not say any of this, because I am the mother, the mother of this beautiful child, this boy of my body, son of my life. The nurse with capable fingers presents me with papers to sign, and I do it. *Sign here. Signature/ Mother.*

In a very short time, I will be nobody's mother. I will not have a relationship with my son except in memory. Faulkner might say that the past is not past, it is not even dead, but Ronan will be dead. And gone. I will write letters to him and he will not reply.

Months after Ronan's death I will see this hospice nurse by accident in an Albuquerque doctor's office and, before she sees me, I will run into the nearest bathroom and vomit in the toilet. This kind woman who will lie about Ronan's time of death so that I have two full hours with him after he dies, washing him, touching him, nobody else in the room, just us. But in this moment, I don't want my son's death to be a part of a whole series of children's deaths, although there are many, and I should have empathy for these nameless parents of other 'neuro-devastated children', but I can't stand to think of these parents of the doomed. If we lived in a fantasy novel, we'd probably have our own planet with a useless force field, impossible to breach, as nobody would ever want to visit. The nurse is sometimes late, dealing with someone else's

crisis; how to get codeine for children when it's normally forbidden; how to manage 'air grabbing', which happens at the last stages of life. I stare at my son, and imagine the eyes closed, the body cold, the lips grabbing. I want to grab with him. I want to make him immortal, put this nurse in his place, or me, or anyone. I want to grip someone's face and push it into the ground. *As a mother*, I'll say, *fuck you.*

Instead I ask, 'where do I sign', and try to remember the way it felt to write my name, and then after it: 'mother'. I will have written my last act as a mother. Sign *here* and *here* and *here*.

– The (Un)Mother –

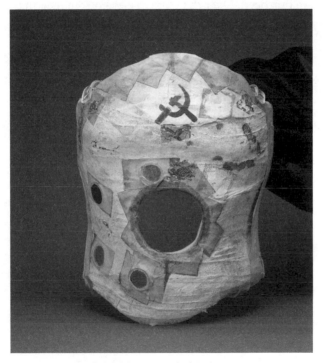

Frida Kahlo, painted plaster corset

H er body is a business of portrayals and depictions and speculations about pain and art and her missing parts and the *one leg forever shorter than the other.* Oh, I know this line so well, this script like a ticker tape I can hook with my teeth and fling at anyone, all in a voice that is placating and sweet. Oh, I am practiced. Over the years in elevators, in meetings, on job interviews, on dates, in the bedroom, the question 'what happened to you?', and my reply, 'one leg was shorter than the other', and then the leg on the floor or hidden under a blanket offered as proof.

Frida's art was not a stand-in for babies, or for giving birth, or for being a mother. It was art. People asked me, after Ronan died, if I felt as though I had given birth to the book about his life.

'No,' I replied. 'I gave birth to a child who died, and before he died, I wrote a book.'

*

When I have my daughter in 2014, a nurse will enter my hospital room one morning to check my C-section wound, pull the sheets off my body like a magician showing his final trick, and say to the intern standing behind her, 'See, she's only half on the bottom any-way.' In my arms, my perfect daughter made by my body. On the intern's face, a look of disbelief.

When Charlie is two, we go to Mexico, and I watch her crawl along the balcony of our rental house in Guanajuato. She is just learning to run, so she alter-

nates between running and literally toddling, trailing her chubby knuckles across the decorations: tracing the beams of a corrugated metal sun; waiting to see if a lizard pinned to the wall is real – will he move toward her if she calls him? She tries. Nothing happens. She doesn't appear to mind. On the balcony across the road, baby clothes hang on a wire and move together, as a unit, in the soft wind. A single piece of tinsel glints hopefully from the edge of a door. The bells ring out. Later, in Guanajuato, she will stand in a blue room and look out over the city, which resembles an arrangement of colorful teeth. Her red-blond head will hover, like an orb, over all she sees. This body, her body, my body divided into perfection. I should be on my knees, thanking someone. Instead, I press her warm body to mine and we look out over the world that is new to me and to her and I say, *This is the best day.* It is my second in Guanajuato, but I am not in the same body as I once was and, yet, of course, this is my body. The mother's body of one child living, another child dead.

Mommy! she says. *This is the best day.*

– The Viewing, London –

I started painting twelve years ago while I was recovering
from an automobile accident that kept me in bed for nearly
a year. In all those years, I've always worked with the
spontaneous impulse of my feeling… Since my themes have
always been my sensations, and the deep reactions that life
has been causing inside me, I've frequently materialized all
that into portraits of myself, which were the most sincere and
real thing that I could do to express how I felt about myself
and what was in front of me.
– Frida Kahlo, Letter to Carlos Chavez, 1939

They come out in droves to see her prosthet-
ics and orthopedic devices and her clothes:
school groups in their crisp uniforms, sharing bags
of sweet and salty snacks and looking bored; sun-
burned German tourists, one wearing a plastic mask
of Donald Trump's face; a woman in a black burka
and black sneakers hurrying toward the museum
steps. I am nervous going in, although I know what
to expect: Frida's legs and casts; the corsets that held
up the bones of her back; some of her best and most
photographed articles of clothing that make up her
quintessential 'look'.

The Victoria and Albert Museum is in South
Kensington, an area of London where apartments

cost millions of pounds, and the white buildings are so spotless in the late September sunshine that they resemble the white buildings in Mojacar, Spain, where my friend Emily and I strolled around on a hot summer day six years before when my son Ronan was still alive and my daughter Charlie was not yet born, and I was experiencing my first manic state. We sat on the beach and she rubbed aloe on my sunburned back and I cried. I loop my arm with hers now.

'I had no idea Frida was so popular,' I say, and I am legitimately surprised. 'I'll bet half of these people didn't know she was an amputee.'

'You've dressed like her,' Em says. It's warm in the first exhibit hall, and we jostle against the other onlookers trying to get close to each photograph or painting or fragment of a framed, handwritten letter for a few long seconds.

Indeed, I have deliberately dressed like Frida, or perhaps in homage to her. It would be ridiculous for an American woman to wear a Tehuana dress, but I have disguised myself in my way, one of several forms of controlled presentation: a denim vintage dress (always vintage, the fabric holding someone else's story that will never be known to me) with a ruffle on the bottom hem and a nipped waist; tights; mid-calf eighties dead stock white go-go boots; gold jewelry draped and layered around the neck and across the chest, understated elsewhere; dark lipstick; a single braid.

'This is my confident get-up,' I say.

'It's working,' she says, and smiles. My mother, seventy-five, and my daughter, four, walk ahead of us, my mom trying to shush Charlie as she cries loudly, 'I want to sit down. This is so boring. I don't like this room.' My mom picks her up and begins strolling around with her, whispering in her ear. She giggles. I wonder what my Mom is saying to her.

The rooms are heaving with people, and Emily and I quickly separate. I am starting to feel hot and awkward, as I often do in art museums, when the pace of viewing is so slow, and people are thinking so hard it's as if they create personal clouds of warmth. It's a miracle that more people don't faint. Walking slowly is the hardest kind of movement for me and, without the momentum of follow through that happens at a quicker clip, I limp noticeably, which makes me feel unmoored from my body. And that makes me nervous. I notice people's stares; people are *staring*. I feel their eyes on me as I limp, then their eyes on the photographs of Frida. A hushed concentration hangs in the room – a palpable sense of people looking at things to try and understand them, or memorize them.

I'm feeling impatient to see the legs and the corsets and the boots. That's more my genre. I move into the second hall, but it's so packed that I'm forced over to the left side, where I stumble into the man in front of me, who catches me as we exchange awkward apologies. When he steps away to reveal a photograph of Frida I have never seen, I feel like someone has

power-punched me in the chest. I literally think of the heavy bag I used to have in the back room of my house in New Mexico, and all the hours I spent beating the shit out of it. I feel like the bag.

I look around for Em – I do not want to stand alone in front of this photograph on the edge of tears – but I don't see her. Charlie is sitting on the lap of one of the guards while my embarrassed mother tries to pry my jet-lagged, stubborn little girl from his arms. 'I'm resting,' Charlie announces, but finally relents and sits next to him on the floor. 'I'm just Charlie,' she tells the guard, who is smiling, and my mom, giving up, sits down next to her on the floor and gives me a little wave.

'She's in traction,' I mouth to my mother, but she can't lip read that far away.

'What?' I see her whisper back, her eyes narrowed, eyebrows raised.

'Traction,' I say loudly, and a few people turn to look at me. My mom shrugs and shakes her head, still confused.

Indeed, Frida is in traction in the photo, which is taken from the side, so you can see that her head is suspended in air, held up and back by the pulley system behind her, the canvas taut against her forehead. Her amputated leg is raised up in a white cast and her hair is long and dark and flowing over the white cotton hospital gown. I am flooded with the memory of how it feels to be held like that, in suspense, literally, and how painful and awkward it is. The ache in the neck

muscles. The blood from the amputated leg rushing down, that feeling that someone is trying to push knowledge into your head through the bone of your forehead with the bone of their hand. How slowly sweat moves through burlap.

In this photograph, Frida is painting. There is a sketchpad in her lap, and a brush in her hand. This is what makes me want to weep. She makes as pain unmakes her. And she has just lost her leg. I am overcome with compassion for her – not pity – and also compassion for myself, which is hard to come by. To my right, encased in glass, are the corsets that propped up the bones in her back after the accident, and for the rest of her life. My own early casts and a back brace I wore briefly after my amputation were made of the same molded plaster that stained easily (which is why the paint is so vivid on Frida's) and was held together by buckled straps made of leather. Frida's amputation was in 1953; mine was in 1978. The straps hanging from the corset shells behind smudge-free glass resemble the straps I remember pissing on, shitting on, washing in the sink with bleach, spraying with rose-scented body splash to try and mask the terrible odor, which only made it worse. Frida died on July 13, 1954; I was born twenty years later, almost to the day, on July 12, 1974. And yet our legs could have been made by the same man.

I hear a conversation between two women behind me:

'It's so sad, so tragic.'

'Isn't it just terrible, the pain she was in?'

'Oh, these awful … devices. But it inspired her to paint.'

'Yes, it made her an artist. All that pain.'

'Mmmmmm.'

'Poor Frida.'

I limp away, desperate to yell at these two middle-aged women who are having a lovely afternoon at the special exhibit at the V&A. I do not. But they are wrong.

A fan, a critic, or just the average person who knows Frida from a tote bag or a refrigerator magnet, has inherited this narrative that pain was her muse and that she should be pitied rather than understood. Pain is what inspired her to paint, this narrative preaches, whether it was the wreckage of her love affair with Diego, or her chronic and constant pain, or losing part of a leg. Art has been codified as her 'therapy'. It is so ridiculous I want to cry or scream, something. Instead, I keep walking. Art from pain is not therapeutic; it is necessary, and the muse is always survival – *through* the pain, not over it, not because of it, and not even despite it.

Going half-mad in Spain was not about being visited by a muse; it was madness, pure and simple, a visitation, a haunting. Screaming out the window of a farmhouse, afraid to kill random bugs on the window-sill because the spirit of my dying boy might be trapped

inside. Pretending to be Kafka, then pretending to be his lover, then pretending to sleep, then wanting to be dead. Wandering along dusty streets, my uneven footsteps lit by the bright moon breaking through, every so often, from the muted haze of a late summer sky in southern Spain.

Other art historians have broken Frida's paintings into categories of those representing real pain and imagined pain. There is no way to calculate what represents more pain: the red leg with its winged painted foot behind the glass, or the photo showing Frida's neck suspended in air, her body deliberately restrained, pulled up in one way, down in another. Which of her thirty medical procedures was the most difficult? Which of her four failed pregnancies hit her the hardest? Yes, she painted in bed. Create or die. That's very different from 'being inspired'.

I do not believe that suffering was Frida's main characteristic, because suffering does not create art, people do. Frida's life was wholly vivid, saturated with all the things that make a life a life: knowledge of suffering; love; sex; friendship; home; travel; laughter; anger and joy; the creation of art.

'It's just so sad,' says one viewer to her companion. 'She could have had such an amazing life.'

They have, I think, totally missed the power of this exhibition. They have looked without really seeing Frida's legs, her winged feet, her corset decorated and shining. This was not the art of inspired sentiment. It

is the art of survival. But only if you see it that way. Otherwise, it all devolves into the typical narrative: the brave, pathetic woman who never had children, whose body was crippled, whose life was ruined.

People have said to me, more times than I can count, 'I would die if I were you.' If I lost a leg. If I lost a child. But I did not die; the body that experiences suffering is the same body that enables life; all of our bodies function within this central – seemingly contradictory – truth.

Some critics and art historians have accused Frida of paying too much attention to her illnesses; some have debated the veracity of her pain, as if they were the architects of the scale. She was accused of allowing her illnesses to displace her maternal drive, and it was a fault, not a triumph, that she gave herself over to the masculine ambition of being a painter.

A diseased woman is a suspicious woman. A grieving mother is a suspicious mother unless she is a virgin and consecrated into the realm of religious impossibility. A disabled woman is not a woman. It's as if the idea – and especially the image – of a disabled woman in the world floats. It is there; no, it is there; and there, or maybe there.

Another wall of portraits at the far end of the gallery: Frida naked from the waist up. Three black-and-white stills of her gazing at the camera while holding alternatively a mirror, a brush, an adornment for her hair. Her breasts are small and spherical and soft-look-

ing. Her shoulders look sculpted and strong below the angle of her jawline. 'Wow', I hear someone say behind me, so close to me it's as if they are whispering in my ear. 'She's actually beautiful. I never thought of her as beautiful.' His wife pulls him along and the same pair of ladies stands next to me again. 'Such a pity she never had children. They would have been beautiful.' And now I let tears blur my vision until people move past me and I hear Charlie saying, 'Mommy! I'm so bored and I want to eat a cookie at the coffee store.' I pick her up and give her tired face a kiss. Behind us, encased in glass, the corset in which Frida cut a round hole as a way to show her miscarriages, to show the place where there was no child, to secretly and privately wear the losses against her, with her, around her, just as any mother would do.

In 1954, a year after her amputation, Frida was dead. Her body, born complete and beautiful, torn into a puzzle that nobody could solve. Most of the world knows her disembodied face as inspirational: printed on t-shirts, socks, aprons, notebooks, backpacks. I would rather wear an image of her winged foot; the incomplete corset; the tattered back brace.

– Leggie –

Five years old, my daughter – ginger hair, freckled nose, pale skin and all energy and fire – sprints across the playground at her school, a sprawling campus set in a stand of orange trees. 'Mommy!' she shouts, pumping her arms near her sides, her two strong legs moving quickly, effortlessly. A little friend runs next to her; they are breathless with excitement and the feeling of being out of breath. They look like textbook active children, two perfect circles of red on their faces from the exertion.

'I was telling her about your leggie,' Charlie says, panting. 'How you have one that's special. She didn't believe me. Tell her it's true!'

The other girl looks me up and down, so curious, so sweet.

'That's right, sweetie,' I say, 'I do have a leggie!'

'Told you!' Charlie says triumphantly to the little girl, who simply says, 'wow', when I pull up the bottom of my jeans to show her the different colored skin.

'It makes my mommy who she is,' Charlie says and then, just like that, the two girls take off, hand in hand, in the direction of the sandbox.

Her comment stuns me, and also opens up a feeling that I began to have in the London museum,

surrounded a second time by the artifacts of Frida's embodiment. It was only after we visited the museum that Charlie began asking questions about my leg, and it was then I could use Frida's story as a way to understand my own enough to tell her, and to talk about my leg in a way that made her understand.

This conversation, impossible without the invention of Leggie, has perhaps made my child unafraid to ask other questions: 'If this world is all that's real, then what comes after?' and 'What does homeless mean?' and 'Who made war?' and 'How is heaven going to work if everybody who has ever lived ends up there?' Charlie knows about her brother who died (and she doesn't say 'passed on', she says 'died'); she knows about Mommy's leg that was lost. Charlie knows about loss even if she has not yet experienced it in her body; someday she will. This is Frida's gift: to acquaint us with our own losses in a way that refuses to hide or sublimate the truth of them. Frida was an artist who refused to be banished to some stereotypical underworld. She made her pain visible in a way she herself chose; the rest stayed hidden. In some ways, her life and her work provided a new method for navigating loss of all kinds: the fracturing of love, the fracturing of a body, loss after loss after loss.

My body is, and always will be, part mechanical machine. This fact is a burden, a gift, a risk, and a reality that can be projected and shifted in ways that I can control and not control. Like all of us who live

and breathe and function in our bodies, composed of so many disparate parts and processes, so many conundrums and solutions: we are all hybrid beings. We are all part of the chaos and unpredictability that is creation, reinvention, and change.

My guiding quest of this journey I have taken with Frida as my imaginary friend is: what can I learn from her? What is she really saying that goes beyond what Margaret Lindauer critiques as 'the entrenched narrative of pain', this singular narrative which has become synonymous with her work *and* her life? What can all of us learn from Frida, no matter our embodiment?

This: Love and bodies come apart. Also, this: Art remains.

IMAGE CREDITS

Other titles from Notting Hill Editions*

My Katherine Mansfield Project
Kirsty Gunn

In 2009 Kirsty Gunn returned to spend the winter in her home town of Wellington, New Zealand, the place where Katherine Mansfield, the writer who inspired her, also grew up. In this lyrical essay she explores the idea of home and belonging.

Things I Don't Want to Know
Deborah Levy

Deborah Levy uses George Orwell's famous list of motives for writing as the jumping-off point for a series of thrilling reflections on the writing life.

Found and Lost: Mittens, Miep, and Shovelfuls of Dirt
Alison Leslie Gold

A compelling memoir from the holocaust writer Alison Leslie Gold, told through a series of letters. The letters tell of her early activism; her descent into addiction and alcoholism; her fateful meeting with Miep Gies (who sheltered the Frank family), and her subsequent recovery.

How Shostakovich Changed My Mind
Stephen Johnson

Music broadcaster Stephen Johnson explores the power of Shostakovich's music and how it gave hope during Stalin's reign of terror. He writes of the healing effect of music on sufferers of mental illness and how Shostakovich's music helped him survive the trials of bipolar disorder.

What Time Is It?
John Berger & Selçuk Demirel

A profound and playful meditation on the illusory nature of time. Illustrated throughout in full colour by Turkish artist Selçuk Demirel in his inventive style and introduced by Berger's friend Maria Nadotti.

Still Life with a Bridle
Zibigniew Herbert

The poet Zbigniew Herbert brings the Dutch 17th century alive: the people, as they bid crippling sums of money for one bulb of a new variety of tulip, and the painters like Torrentius who was persecuted for heresy and whose paintings disappeared – all but one, named 'Still Life with a Bridle'.

Essays on the Self by Virginia Woolf
Introduced by Joanna Kavenna

In these thirteen essays, Woolf celebrates the urgency of the present; and explores the nature of the finite self ('Who am I?' 'Who is everybody else'?) and how individual experience might be relayed.

Mentored by a Madman: The William Burroughs Experiment
A. J. Lees

Neuoscientist A.J. Lees explains how William Burroughs, author of *Naked Lunch* and troubled drug addict, inspired him to find new treatments for Parkinson's Disease.

'The comparison with the late, great Oliver Sacks is entirely just.' – Raymond Tallis

*All titles are available in the UK, and some titles are available in the rest of the world. For more information please visit www.nottinghilleditions.com

A selection of our titles is distributed in the US and Canada by New York Review Books. For more information on available titles please visit www.nyrb.com